AUGUSTUS JOHN

by

John Rothenstein

AMS PRESS

NEW YORK

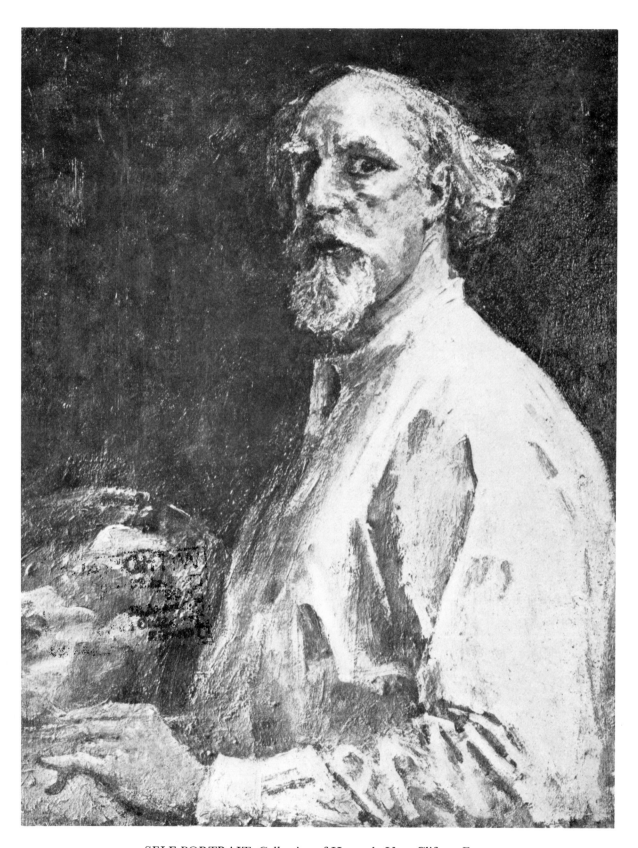

SELF-PORTRAIT. Collection of Harry de Vere Clifton, Esq.

AUGUSTUS JOHN

BY

JOHN ROTHENSTEIN

MCMXLV

OXFORD & LONDON

PHAIDON PRESS LTD

Library of Congress Cataloging in Publication Data

John, Augustus Edwin, 1878-1961.
 Augustus John.

 Reprint of the 1945 ed. published by Phaidon Press,
Oxford, in series: British artists.
 1. John, Augustus Edwin, 1878-1961. I. Rothenstein,
John Knewstub Maurice, Sir, 1901-
ND497.J6R6 1976 759.2 75-41158
ISBN 0-404-14560-4

Reprinted from an original in the collections
of the Ohio State University Library

From the second edition of 1945, Oxford and London
First AMS edition published in 1976
Manufactured in the United States of America

AMS PRESS INC.
NEW YORK, N.Y.

INTRODUCTION

MOST of the best painting of our time is the product of the wise and intensive cultivation of moderate talent; Augustus John's on the other hand might seem to arise from the prodigal cultivation of an egregious talent. That this artist is a man of genius posterity will scarcely question, though it may well speculate as to the degree to which his genius has been fulfilled.

For a generation or more there has been a decline in the capacity of painters for the actual handling of paint. This does not mean that the whole art of painting has declined, but that painters attempt to find compensation for a diminished manual dexterity in greater thoughtfulness, and rely rather more than they formerly did on the meticulous designing of pictures, and rather less on their accomplished execution. The young man, confident in his strength, goes impetuously for his objective, surmounting some obstacles, brushing others aside, but the old man plans his journey carefully in advance and waits for the propitious moment. Paradoxically it is sixty-six year old John who, to a greater degree than any other British painter alive, exhibits the impetuosity and confidence of youth. Since his student days he has had immense technical resources at his command. The early possession of such resources decisively affected his development, for, able generally to realize any aim he sets himself, he has never felt the need for elaborate planning or for the cultivation of an esoteric taste; still less (in spite of possessing an intellect of exceptional range and power) of protective aesthetic theories, on which many of his younger contemporaries rely. Generally unhampered then by technical obstacles, John's art has developed freely, and it reveals with singular completeness the artist's personality. For if 'the style is the man', the style of the man who is able to set down his emotions, his intuitions, his ideas, without greatly troubling himself about the means he employs, reveals more than that of the man who hesitates, qualifies, and polishes, for a style of this kind may in fact hide

5

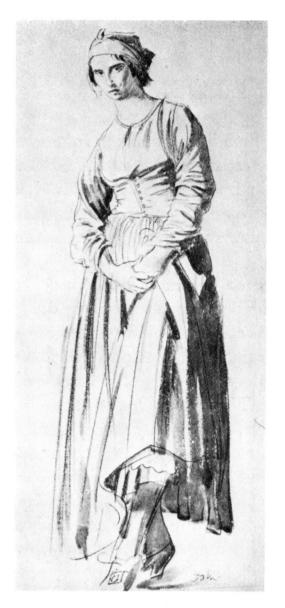

STUDY OF DRAPED FIGURE
Pencil and wash. The Tate Gallery.

almost as much as it reveals. 'Do not be troubled for a language', Delacroix said; 'cultivate your soul and she will show herself.' Confidently entrusting to his preternaturally gifted hand and eye the execution of any orders they receive, John has been able to follow Delacroix' precept, though the word 'soul' does not perhaps express precisely what John has cultivated. This may be said to be a splendid and very personal vision. Something of the largeness, the mystery, the penetration, the robustness and the candour which mark this vision is revealed in the opening passage of John's lately published *Fragment of an Autobiography* in which, speaking as a writer, he says: 'Without premeditation and in an indifferent light we set to work at one corner of the immense canvas, upon which, as it stretches into darkness, we are to weave with so little skill the tapestry of our lives. The picture will never be finished and is marred by many confused, threadbare or mutilated passages, but at last and from a certain distance a Pattern will emerge which, though not of our designing, is the Key and the signature of Personality.'

John has no theories nor is he the inventor of secret processes, but he divines and appropriates those of other artists when he requires them. This he is able with impunity to do as often as he wishes, or almost as often, for there is little danger of the integrity of a personality so pronounced and self-assured being impaired by what it borrows. I add the qualification almost as often, because there is one man under whose spell John seems at moments

to work as though dreaming and no longer entirely himself. This is El Greco, whose ecstatic rhetoric has captivated our generation. The others from whom John has learnt most are Goya, Rembrandt, Puvis de Chavannes, the Impressionists, and Conder and Innes.

First and foremost John is a draughtsman and his painting is most masterly when it approximates most closely to drawing. The majority of his best paintings have the strong contours and the clearly defined forms which belong to drawing. Especially is this true of the painting of his early and middle years. The vision of painters tends to become broader and more generalized with age. One has only to compare the later with the youthful work of painters who have in, other respects so little in common as Titian, Rembrandt, Turner, and Corot to see how marked is this development. Of recent years John's vision also has undergone the same change. Not only his painting but even his drawing has grown broader, more generalized, more 'painterly', though he still remains essentially a draughtsman.

As a draughtsman he stands out as the representative of a generation of fine draughtsmen, but as a designer, as I have already suggested, he has little in common with his contemporaries. At the beginning of this essay an

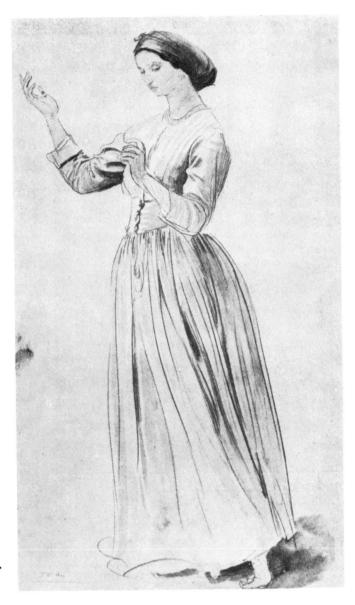

STUDY OF DRAPED FIGURE
Pencil and wash drawing. The Tate Gallery.

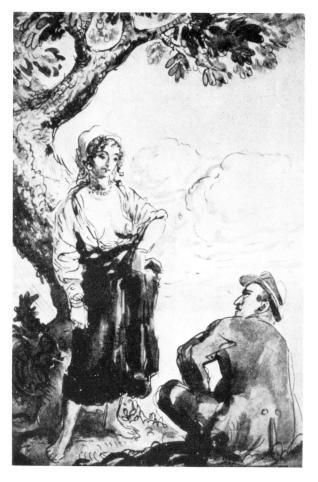

ILLUSTRATION TO 'OMAR'
Pen and wash drawing.

allusion was made to the tendency among painters of the present day to compensate for the general decline in manual dexterity by giving closer attention to design, or more recently and in the most intimate sense to subject matter. Since Cézanne there has existed a conviction with regard to the importance of design that is without parallel. In Europe and America there has grown up a generation of painters among whom there are many who have embraced the heresy of regarding design as a science. Yet the best contemporary designs have an extraordinary precision; remove a petal from an oleander, alter, by a hair's breadth, the relation of a vermouth bottle to a loaf of bread, and the entire effect is lost.

No living artist is further than John from sharing this widespread 'scientific' attitude towards design. Wyndham Lewis once called him 'a great man-of-action into whose hand the fairies stuck a brush instead of a sword'. The description is to the point: John is a painter-of-action who paints so naturally that he infinitely prefers the painting of pictures to the designing of them. This does not imply that his ability as a designer is inadequate, but rather that his vision is of too spontaneous and dynamic a kind to be susceptible of scientific organization. Like the periods of a great natural orator, John's designs are improvisations. The fetters of 'scientific' design would confine John's vision just as the classical conventions, so appropriate to the formal dramas of Corneille and Racine, were felt by Hugo and Lamartine to obstruct the liberty of expression which their genius demanded. John belongs by temperament to

8

the succession of the grandiose and prolific wall painters: he is a more romantic, more ardent, less artificial Tiepolo. But it is his misfortune to live, unlike Tiepolo, under conditions which allow few and meagre opportunities for painting on a great scale. Throughout his life the full exercise of the rarest of his gifts has been denied him. When the infrequent occasion comes his way, how avidly he seizes it! The immense cartoon *Galway* (plate 81), which covers nearly four hundred square feet, he completed, he told me, in a single week.

Few living artists are able to work as swiftly; indeed he never manifests his genius more clearly than when he is subject to one of what Wyndham Lewis terms his 'fits

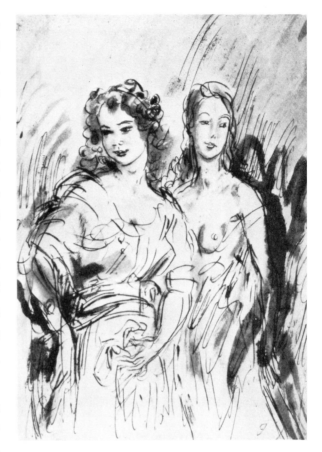

THE TWO FRIENDS
Pen and wash drawing.

of seeing'. It is when he repaints, in the hope of obtaining greater intensity or definition, that he sometimes falters. Earlier references to his conspicuous skill, and to the ease with which he has so often realized his aims, does not mean that he has not had difficulties to contend with; still less that he has never experienced failure. On the contrary, there is a certain weakness inherent in the very nature of his genius. Spontaneous invention with him depends upon intense emotion, and intense emotion fluctuates. In a work of art that has been meticulously planned, and its every detail worked out in advance, the conversion, at a critical moment, of failure into success is often a matter of some slight adjustment; but in an improvisation a mistake can be redeemed, as a rule, only by a painful struggle of which the outcome is uncertain. Often John carries everything before him in a first brilliant assault, and produces masterpieces almost without effort, but there are times

9

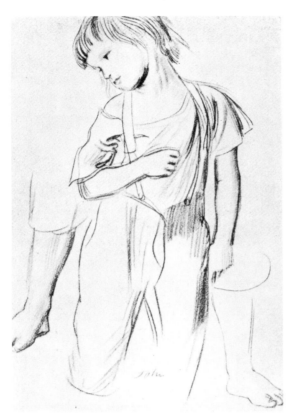

STUDY OF EDWIN. *Pencil drawing.*

when no efforts, however tenacious or prolonged, suffice to set right some seemingly insignificant error.

As a technician John is traditional and eclectic, and distinguished by the brilliance and the audacity with which he uses methods already perfected, rather than for innovation, but it is on account of his vision that he must be accorded a unique position among living British painters. Something of its magic is reflected in the passage already quoted from the *Fragment of an Autobiography*. Attention is drawn to another aspect of it in a notice by Wyndham Lewis of an exhibition held some years ago, of a group of his West Indian subjects. 'Mr. John opens his large blue eyes, and a dusky head bursts into them. He has his brushes and his canvas handy. His large blue eyes hold fast the dusky object, while his brushes stamp out on the canvas a replica of what he sees.

'In describing Mr. Augustus John's assault upon these Negro belles— his optical assault, as his large blue eyes first fall upon them in Jamaica— I was indicating what is, in fact, a good deal his method of work. Nature is for him like a tremendous carnival, in the midst of which he finds himself. But there is nothing of the spectator about Mr. John. He is very much a part of the saturnalia. And it is only because he enjoys it so tremendously that he is moved to report upon it—in a fever of optical emotion, before the object selected passes on and is lost in the crowd.

'For nothing is there for very long, so that he can brood upon it. Mr. John is Heracleitean by temperament. And there has always been something epileptic in its intensity in this dazzling hit-or-miss reporting of his. When, however, I use the word epileptic (and just now I spoke of his *fits of seeing*)

I would not have you understand by that anything pathologic. Nothing could be further from the truth. It is an extremely robust convulsion that occurs. Every time it happens, one is impelled to congratulate him. And we should also congratulate ourselves that an eye so demoniac and yet so perfectly healthy is among us, producing image after image of unusual power and beauty.'

One of John's transcendent qualities, although suggested by Lewis' tribute, calls for emphasis: this is his power of expressing experiences of wide human application rather than those that are particular to one place, time or person. Most positively, perhaps, he expresses the spirit which exists at all times and which incites men and women to live—with the minimum regard to safety—adventurous, abundant lives; the nomadic fiercely independent bohemian spirit most commonly to be found among the gipsies. It was neither chance nor casual romanticism that drew John to these nomads, but his apprehension of a community of outlook between himself and them. 'The absolute isolation of the gipsies seemed to me the rarest and most unattainable thing in the world', he wrote.

The early part of John's life as a painter was devoted mainly to the subjects best adapted to the expression of this spirit. As a student at the Slade School he used to discover, among gipsies, tramps and costers, strange characters whom he took for models. In the summer holidays in remote regions of Wales he made studies of primitive peasants, the unconscious purveyors of strains of wild poetry which come singing out in his drawings. In Liverpool, where he spent a year and more as a teacher of art, it was the homeless wanderers by the

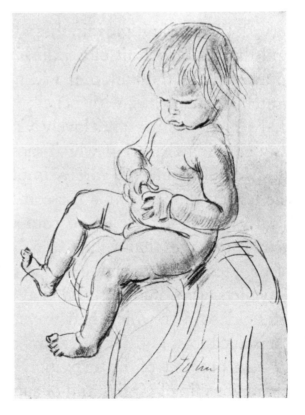

STUDY OF ROMILLY. *Pencil drawing.*

11

docks, tattered, wayward old men in whom he sought and found a novel and expressive magic.

Standardized education, the mechanization of most men's work, and a growing uniformity of opinion induced by wireless and the Press, although they may be making for a better-ordered social system, are inimical to the bohemian spirit. The men, women, and children, and the landscape also, in whom this declining spirit is in some measure conspicuous, have been John's chosen subjects.

In his earlier days he sought them out; later on he has had to content himself with emphasizing aspects of this spirit in whatever sitters have knocked at his studio door. For in England to-day almost every painter who needs to live by painting must accept commissions for portraits; and since it happens that those who can afford to give such commissions are sometimes lacking in the spirit which most moves John, it is in his earlier portraits of gipsies, tramps, and costers that this most spontaneously reveals itself.

If John had continued to devote himself to the portrayal of types of men and women who have resisted the pressure of urban civilization, and preserved their primitive impulses, we should possess a uniquely splendid and dramatic portrait of a vanishing aspect of Britain. But life is not kind to artists, and though John will never complete this portrait, we must be grateful that he has, with pencil, brush and etching needle, allowed us to share his haunting and lovely vision of a freer, braver, more abundant way of living than that which most of us know.

Men of genius are rarely simple. The more closely we scrutinize them the less do they resemble the common conception of them and the more clearly are they seen to be composed of conflicting elements. Macaulay acutely observes that Milton, the defender of the regicides, and the scourge of prelates, was 'under the influence of all the feelings by which the gallant Cavaliers were misled'; and that he had the same affection as they for 'the old banner which had waved in so many battles over the heads of their ancestors, and for the altars at which they had received their brides'.

On account of his extreme independence in speech and action, his championship of gipsies and of sundry unpopular causes, the common conception of John defines him as a man in rebellion against the established

order of things; above all against traditional culture. This conception of him I believe to be mistaken, and plausible only because of the incompatibility between his outlook and the particular conditions which prevail to-day.

This happens to be a time when the lion is apt to be an outlaw, and sheep, by virtue of their superior capacity for co-operation, inherit the earth. This tends to be true not only in the arts, but of almost every other sphere of human endeavour. The issue of the struggle in which we are engaged is one of life and death, not for us as individuals only, but

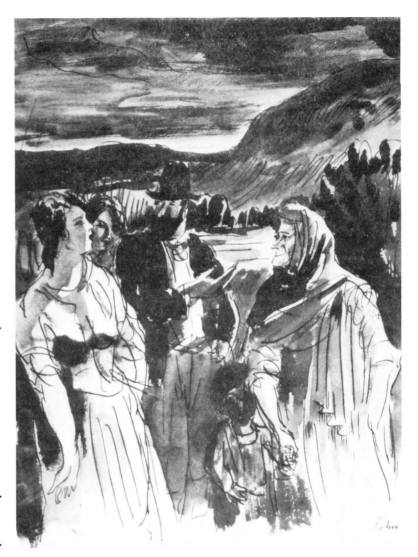

GROUP OF PEASANTS IN ALTERCATION
Pen and wash drawing.

for all those 'who speak the tongue that Shakespeare spake; the faith and morals hold that Milton held', yet we waited until irretrievable disaster had all but overtaken us before we placed our destinies in the only hands strong enough to guide them.

In other and more propitious times there would have been an honoured place for John among those who served the established order: he would have glorified God on the walls of churches, or have celebrated, on the walls of palaces, the triumphs of princes. Who indeed reveals in his official portraiture a higher sense of civic dignity than John? No better official

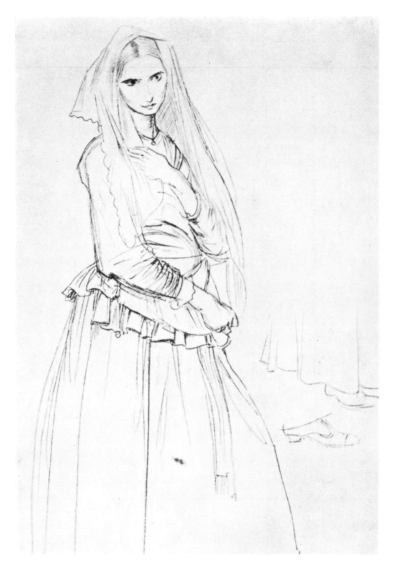

GIRL IN MANTILLA. *Pencil drawing.*

portrait has been painted anywhere during the present century than his *Judge Dowdall, as Lord Mayor of Liverpool* (plate 42), which Liverpool rejected. But democracies (outside Mexico and the United States) would seem to be indifferent whether their achievements are celebrated; so the triumph of law, the march of science, as well as a hundred less grandiose, more human and lively, yet highly significant aspects of contemporary civilization have been without their painters.

Those whom it pleases to use the art of the past as a stick with which to beat the art of the present and to reproach modern artists with the relative triviality of their subjects, and with the restricted scale on which they work, have taken up the cudgels under a delusion. The times when the arts have flourished with the greatest splendour have been those times when the layman gave the artist both the encouragement and the means to work on a heroic scale. Michelangelo was actually unwilling to undertake the painting of the Sistine Chapel: he was compelled by an imperious patron to give the world what has proved to be one of its supreme works of art.

It is unjust to blame artists for failing to paint large and elaborate

paintings on speculation; such works must be commissioned. And to-day neither governments nor private corporations give painters opportunities remotely comparable with those which their predecessors enjoyed for undertaking great subjects. Augustus John, a man splendidly equipped to carry out great public projects, has not been given a single adequate opportunity to make the attempt. I remember him saying, in opening the exhibition of photographs of contemporary British wall-paintings at the Tate Gallery in 1939: 'When one thinks of painting on great expanses of wall, painting of other kinds seems hardly worth doing'; and more recently, at a restaurant: 'I suppose they'd charge a lot to let Matt Smith and me paint decorations on these walls.'

If by some miracle great public works of art were now imperatively required, we should be compelled to

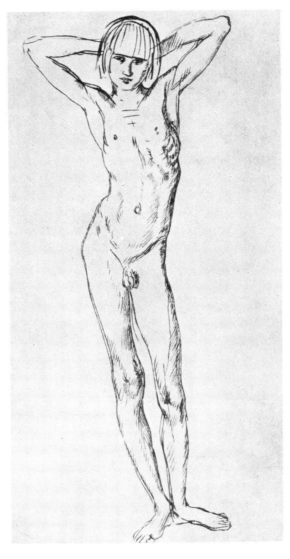

NUDE BOY. *Pen drawing.*

send for John as we were at last compelled to send for Churchill, but as no such miracle is likely to take place this man must remain frustrated, and for this no honours and dignities can make amends. Since his big compositions have been undertaken on his own initiative or at the instigation of friends by no means certain to buy them, it is hardly surprising if, for all their magnificence, they have a fragmentary character.

The *Study for a Canadian War Memorial*, an immense and complex charcoal composition, peopled by scores of figures, was never carried out. The *Galway*, already mentioned, is a gigantic sketch. The vivid and animated *Mumpers* (plate 82) could have been carried much further. This is also

15

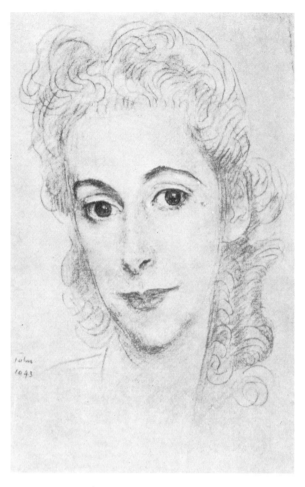

CARMEN
Chalk drawing. Collection of T. S. Ison, Esq.

true of the *Lyric Fantasy* (plates 83 and 35), a large composition more highly charged with a mysterious poetry than any of his other works of a similar kind. The subject of its poetry is a group of wild, lovely girls —to whom he has given something of the fierce and lofty isolation which he envied in the gipsies as 'the rarest and most unattainable thing in the world'—and some ravishing children in an arid but enchanted landscape. For one who venerates John's genius it is difficult to look at this superb painting without sadness, for it represents something unique in our time, but it remains unfulfilled, not through the artist's fault but ours.

Of late years there has grown up a habit of referring to all big paintings, whatever their character, as decorations. When the artist's intention in painting a big picture has been the ornamentation of a given space—whether with human figures, or with pilasters-and-garlands, lifebelts, cocktail-shakers-and-burning-cigarettes—it is properly called a decoration. But with pure decoration John's big paintings have as little to do as Michelangelo's; they are, in effect, big easel pictures, less important for their decorative qualities than as expressions of a powerful mind.

The big picture imposes a searching test upon the painter: should he lack fluency it will appear more laboured than a small one; should he lack capacity for design, it will be less coherent; above all, unless his creative impulse is rich and abundant, it will be a void which no multiplicity of incident, no quality of paint, can fill. John suffers from none of these deficiencies. The *Study for a Canadian War Memorial* shows with what

16

apparent ease he is able to fill—without crowding—a vast surface with figures and incident. Yet these big compositions of his are not free from defects. In some of them the foreground has not been given sufficient strength to support the weight of the design as a whole, in others a triumphant forward sweep has received a mysterious check, and what might have been a sublime achievement remains a splendid gesture. Even the *Lyric Fantasy,* surely one of the great British paintings, is regarded by the artist himself as incomplete.

This painting's most notable quality, the singularly poetic relationship between the figures and the landscape, is a theme which John has developed in a series of paintings of another kind. As a

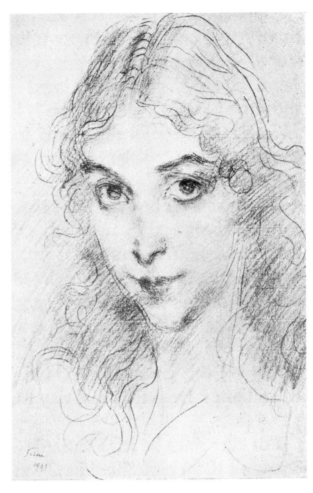

ELISE
Chalk drawing. Collection of W. S. Robinson, Esq.

young man he became friends with James Dickson Innes, a painter with a passion for pure, vivid colours and for mountains. Innes had an original and lyrical vision, and his passion for mountains, those of his native Wales (he was a fellow-countryman of John's) or of the South of France for preference, burned with an intensity often found among men who are conscious of having much to do and little time to do it in, for he was consumptive, and he died at the age of twenty-seven. John, who has always learned so much and borrowed so freely from the old masters, has been singularly little affected by living painters, of whom only two have made an appreciable contribution to his art. Of these, one was Charles Conder, who, at the turn of the century, when an imaginative was competing with a realistic faction for the allegiance of the rising generation, strengthened John's faith in the validity of the

17

imagination. The other was Innes, whose romantic vision of mountain country was an inspiration to John, who first assimilated and then enhanced it. For among glowing, exotic, Innes-conceived mountains John placed figures. Conder had painted figures in landscape constantly, but the landscape in which these figures idle and dream is the artificial landscape of Watteau. Between the figures of John, and of Innes (who, fired by John's example, introduced figures also) and their mountains a mysterious sympathy exists.

In the course of a few enchanted years, spent now in Wales, now in the South of France, the two artists (who were joined by the Australian Derwent Lees, an elegant artist but one who derived his inspiration from his more gifted companions) painted a group of small pictures of singular beauty. And when Innes died, and Lees had ceased to paint, and the focus of John's interest changed, something profoundly original and lovely went out of British painting, and left it colder and more prosaic. The importance of this group of romantic paintings has yet to receive adequate recognition; I hope that one day there will be a special gallery for them at the Tate.

But ever since he left the Slade School (where he was a student from 1894 until 1899) portraiture has been John's chief field of activity. England is the portrait-painter's paradise: from the sixteenth century onwards she has given not only to native portrait-painters, but to a long succession of foreigners also, full scope for their talent. The death of Lawrence seems to mark a singular change in the history of portrait painting. Until about 1830 the best exponents of this art were professionals. No amateurs rivalled Holbein, Van Dyck, Lely, Kneller, Gainsborough, Reynolds or Lawrence himself, but since then amateurs have painted the outstanding portraits. Few portraits by professionals are comparable with Stevens' *Mrs. Collman*, Watts' gallery of great Victorians, Whistler's *Miss Cecily Alexander*, Sickert's *George Moore*, Steer's *Mrs. Raynes*, Wyndham Lewis' *Miss Edith Sitwell* or *Ezra Pound*, or Stanley Spencer's early *Self Portrait*. Like his contemporaries McEvoy and Orpen (who began as genre painters and turned professional portrait-painters later on) John, especially during the latter part of his life, has painted great numbers of portraits, but, unlike these two, he may be

said (though the distinction is a fine one) to have remained something of an amateur, for he is constantly at work on compositions large and small, flower-pieces, landscapes and drawings of the figure, and from time to time he loses interest in commissioned portraits and abandons them, a course which a 'pro' would be unlikely to adopt. Change of subject preserves the spontaneity of his response to the drama of faces.

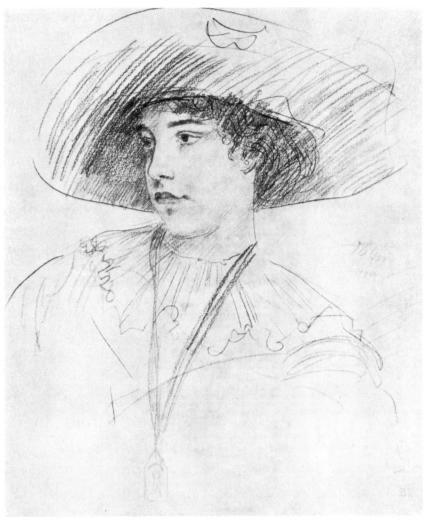

PORTRAIT OF AN ARGENTINE LADY. *Pencil drawing.*

The portrait-painter of the epoch which Lawrence brought to an end was sustained, during spells of lassitude and indifference (to which most artists are subject) by the momentum of a workmanlike and dignified tradition: but the waning of that tradition left the painter face to face with his sitter, dependent, to an extent which his predecessors never were, on his personal response to the features before him, on his power to peer deeply into the character which they mask or reveal. Very rarely is a man's response to faces, or his understanding of them, sufficiently powerful and sustained as to enable him to make it his whole profession, and he who paints little or nothing except portraits, deadens by exploiting this response. To paint portraits supremely well it would seem to be wise to refrain from painting them too often.

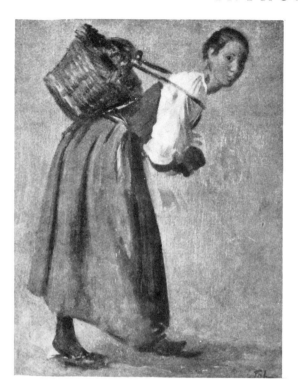

AN EQUIHEN FISHERGIRL. *Oil.*
Collection of the Right Hon. Vincent Massey, P.C.

A passionate preoccupation with portraiture has only occasionally tempted John to over-indulge it, or to exploit it for the benefit of those who are eager to purchase the immortality which at certain moments it lies in his power to confer. At such auspicious moments he gives splendid expression to the qualities of nobility, strength, courage, wisdom, candour and pride in his sitters, but should they happen to possess none of these, he is able to make little of them. But his portraits are not therefore merely romantic tributes to the elements of greatness which he discerns; they rarely suffer from the absence of the critical spirit, or from the complacent touch of personal approbation which characterizes the great Victorians of Watts. John's portraits are the products of a more sceptical nature and a less reverent age. Watts portrays select spirits, as almost wholly noble; John, whose sitters are more arbitrarily chosen, portrays the noble qualities in men and women whose natures on balance are as often base as noble. And where Watts brings a grave and exalted mind to bear upon his sitters, John comprehends his with a flame-like intuition, as in the miraculous *Joseph Hone* (plate 54), the *Robin* (plate 34), and the *David* (plate 36).

Genius which is intuitive and spontaneous is of necessity uneven in its achievement. If John's crowded annals have failures to record, in his inspired moments no living British painter so nearly approaches the grandeur and radiance of vision, the understanding of the human drama, or the power of hand and eye, of the great masters of the past.

LIST OF THE PLATES

LIST OF THE PLATES

ACKNOWLEDGMENTS

THE thanks of the Editor and Author are due to Mr. Augustus John for many valuable suggestions with regard to the choice of illustrations, to Mr. Dudley Tooth for his general assistance, and to owners of pictures, both public and private, for their ready co-operation.

INDEX OF COLLECTIONS

THE PLATES

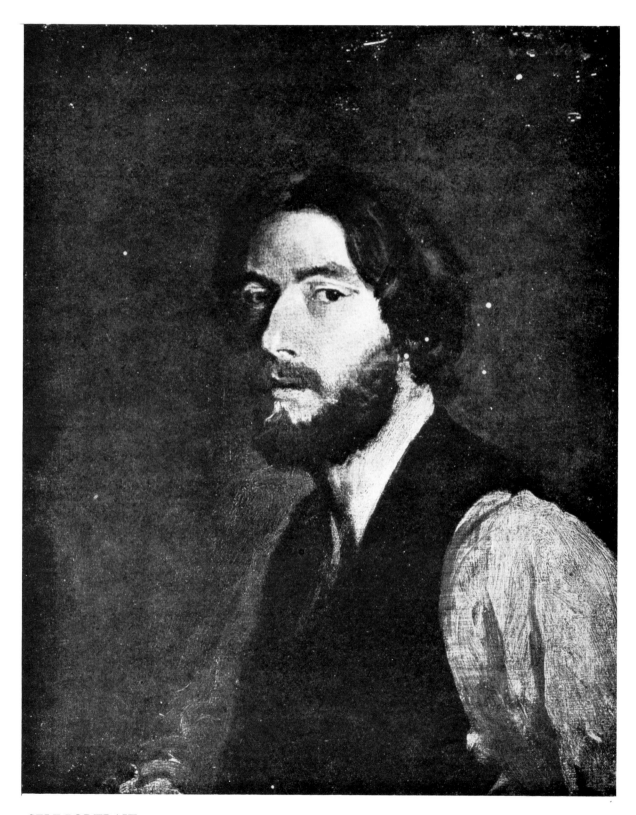

1. SELF-PORTRAIT *c.* 1901

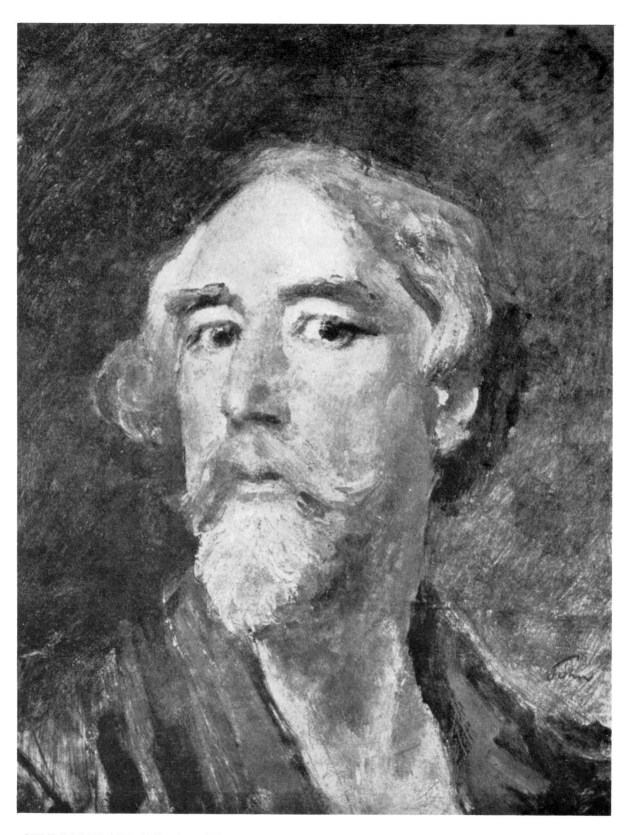

2. SELF-PORTRAIT. Collection of F. W. Bravington, Esq.

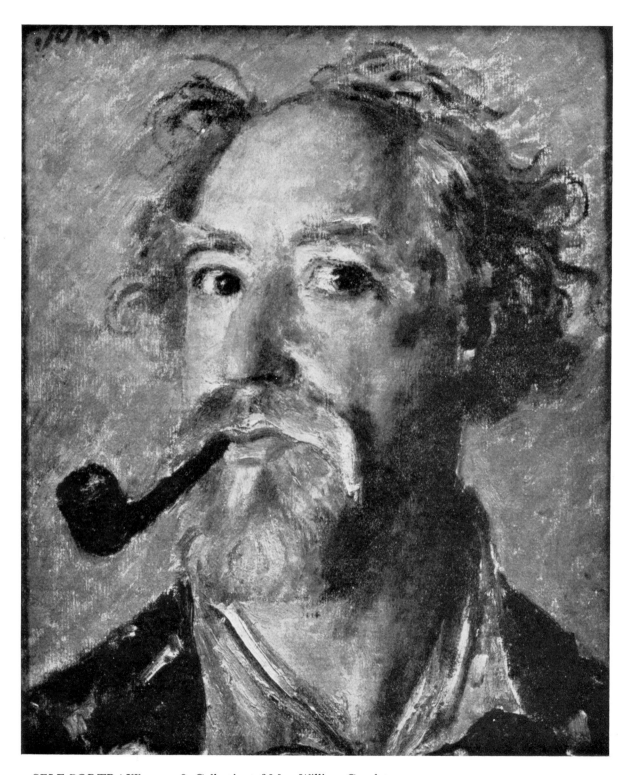

3. SELF-PORTRAIT. *c.* 1938. Collection of Mrs. William Cazalet

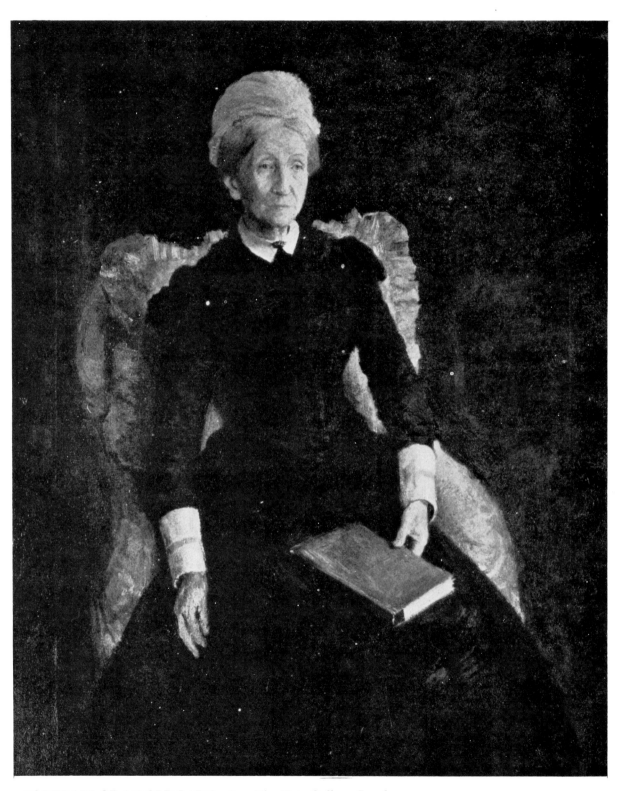

4. PORTRAIT OF AN OLD LADY. 1899. The Tate Gallery, London

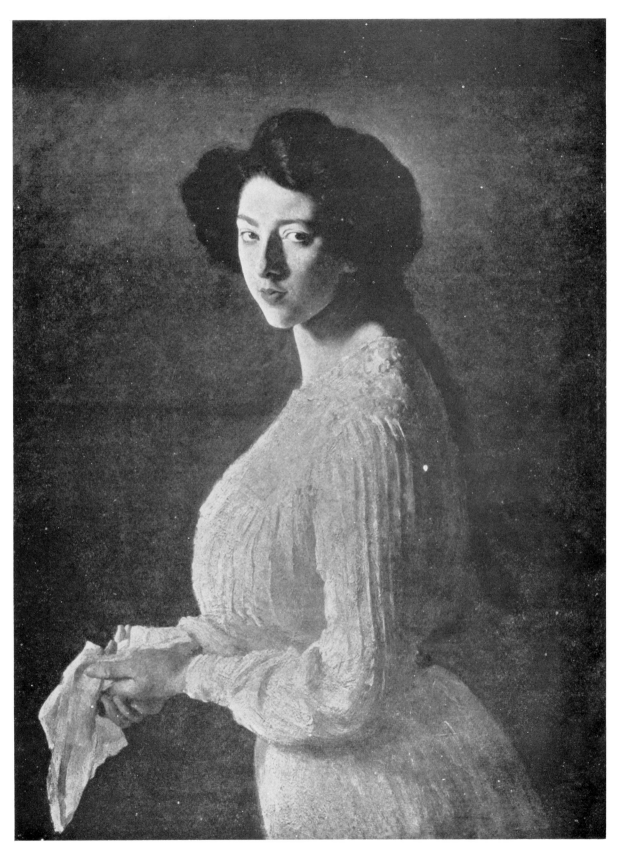

5. PORTRAIT OF ESTELLA DOLORES CERUTTI. *c.* 1900. City Art Gallery, Manchester

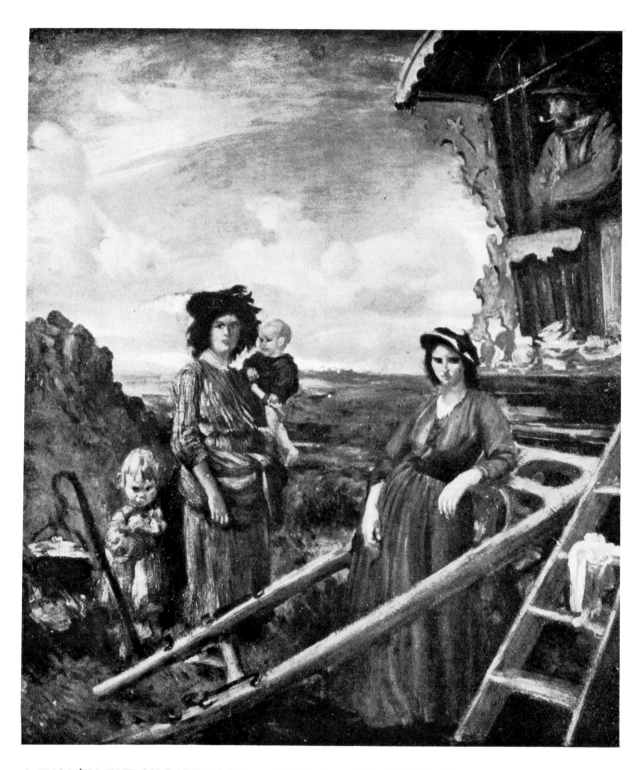

6. ENCAMPMENT ON DARTMOOR. 1906. Collection of Mrs. E. J. Hesslein

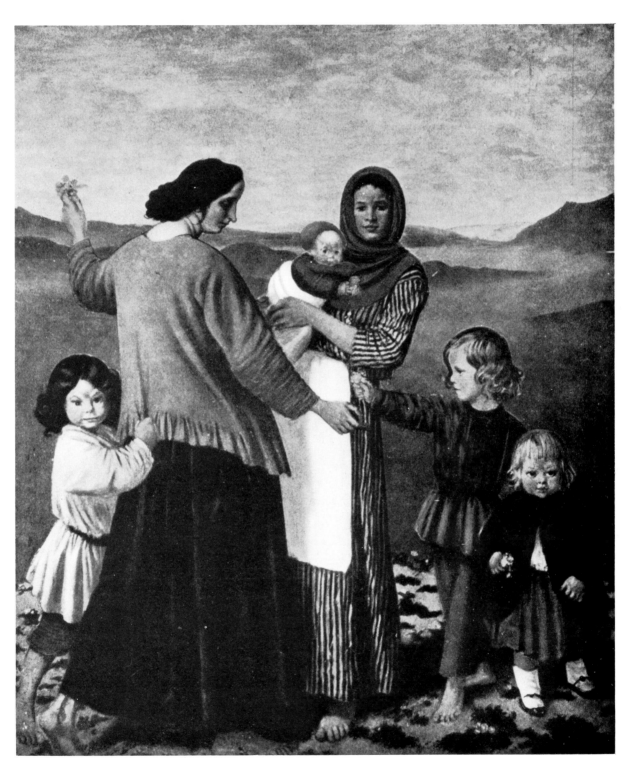

7. FAMILY GROUP. Municipal Gallery of Modern Art, Dublin

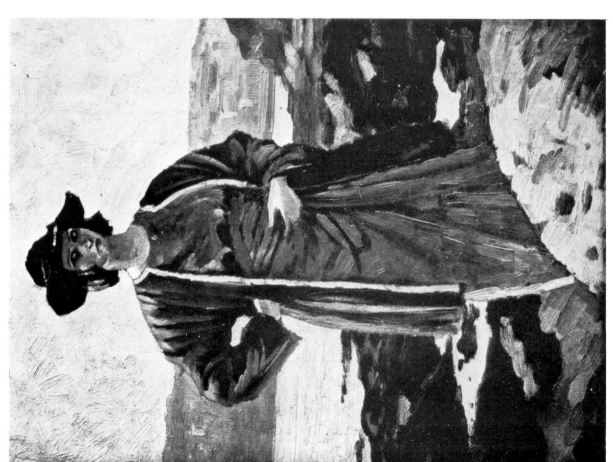

8. SKETCH AT FALMOUTH. Collection of Mrs. Kroyer-Kielberg

9. LILY IN NORTH WALES. Collection of Mrs. Cyril Kleinwort

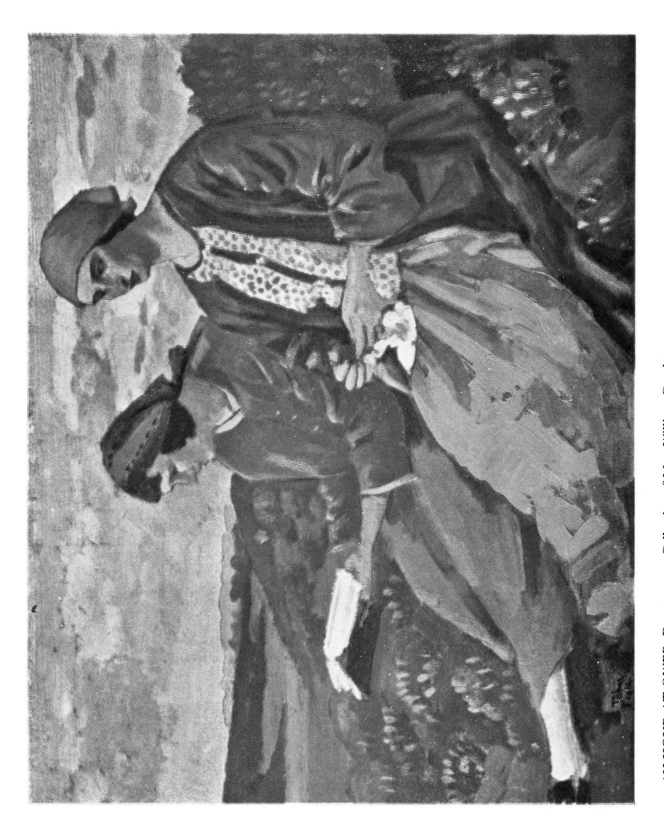

10. AN HOUR AT OWER, Dorset. 1914. Collection of Mrs. William Cazalet

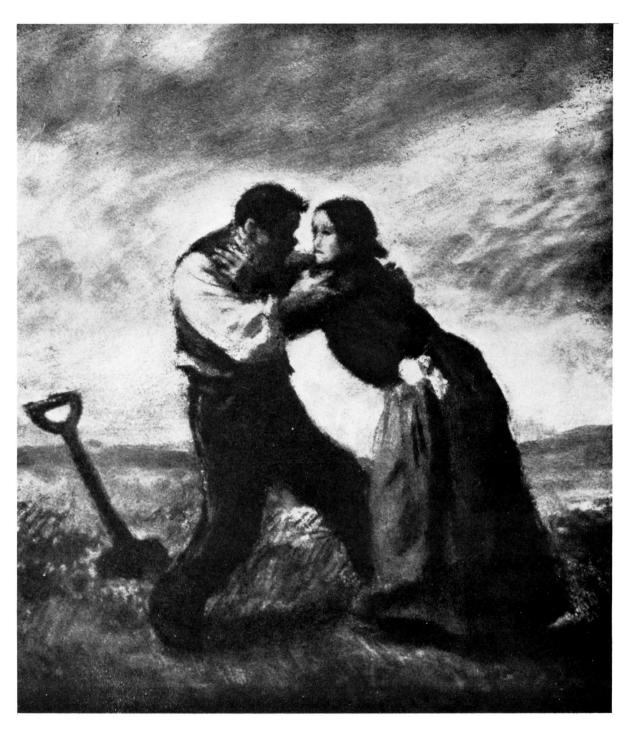

11. RUSTIC IDYLL. Pastel. *c.* 1903. Collection of Bernard Falk, Esq.

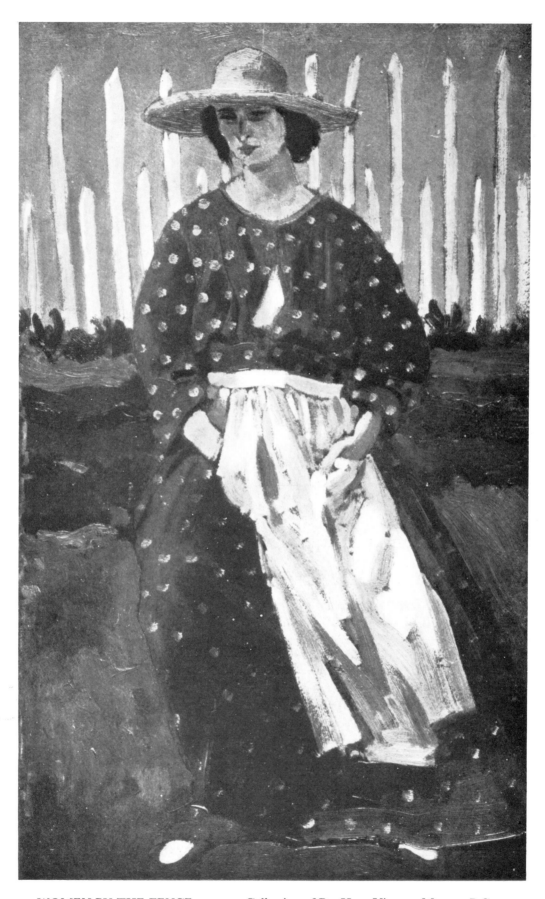

12. WOMEN BY THE FENCE. *c.* 1910. Collection of Rt. Hon. Vincent Massey, P.C.

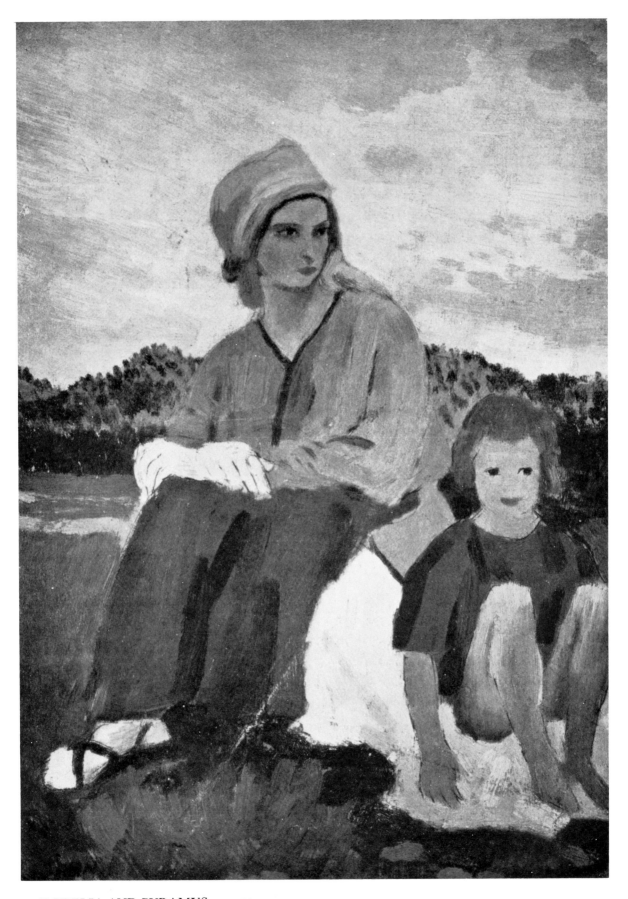

13. DORELIA AND PYRAMUS. *c.* 1909.

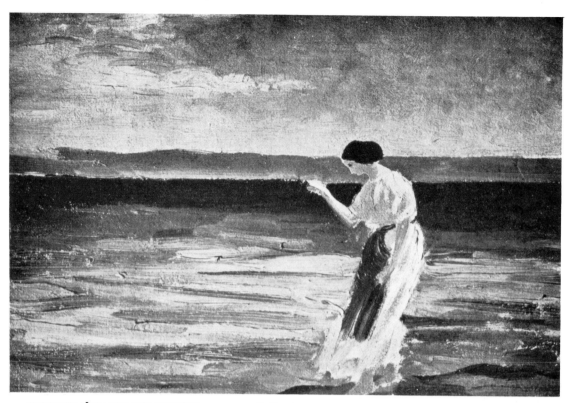

14. BY THE ÉTANG DE BERRE. *c.* 1910. Collection of Thomas F. L. Stevenson, Esq.

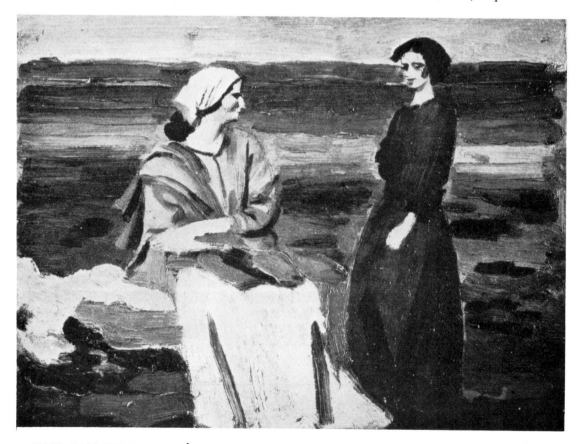

15. TWO WOMEN BY THE ÉTANG DE BERRE. 1910. Collection of Hart Massey, Esq.

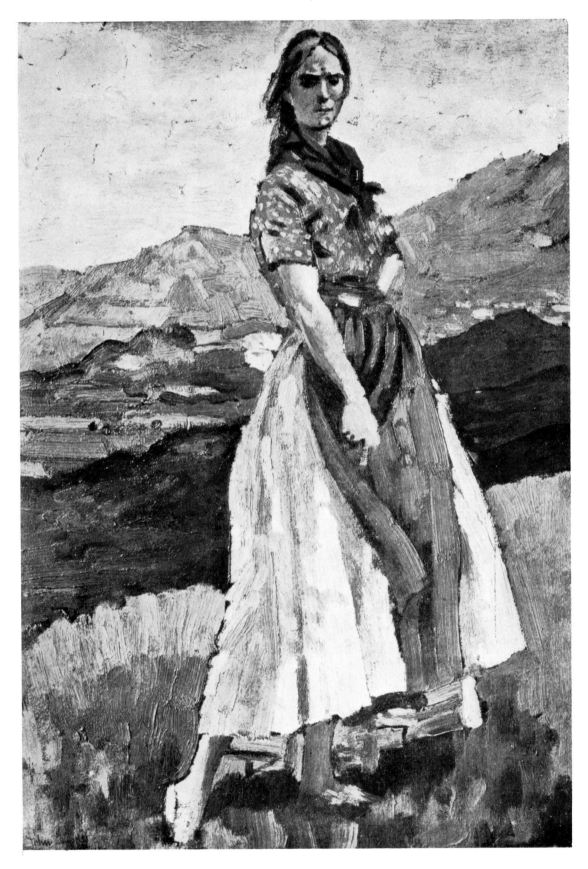

16. LILY AT TAN-Y-GRISIAU

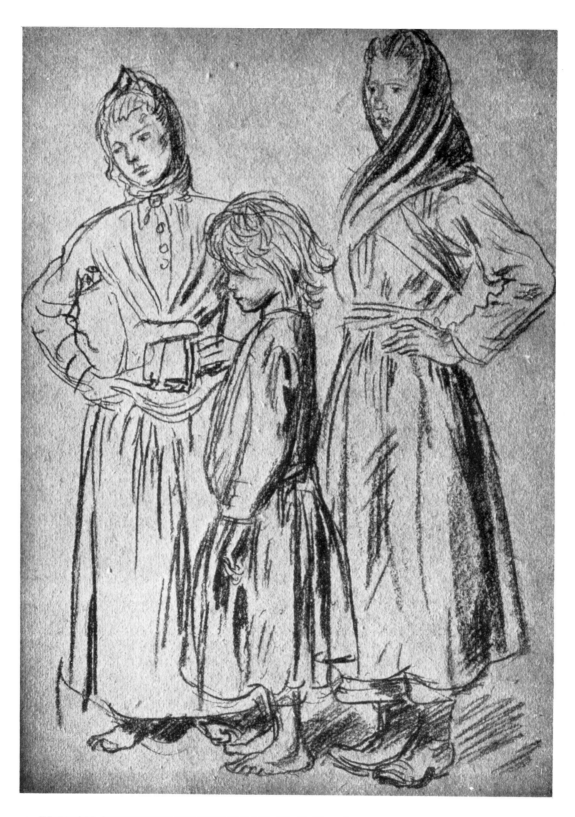

17. FRENCH CHILDREN OF THE ROAD. Chalk Drawing

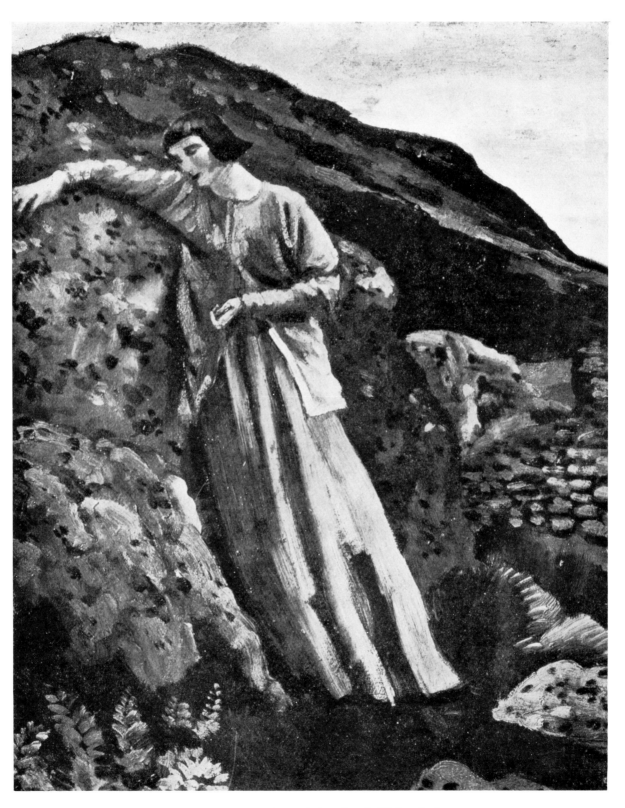

18. SKETCH IN CORNWALL. National Gallery of New South Wales, Sydney

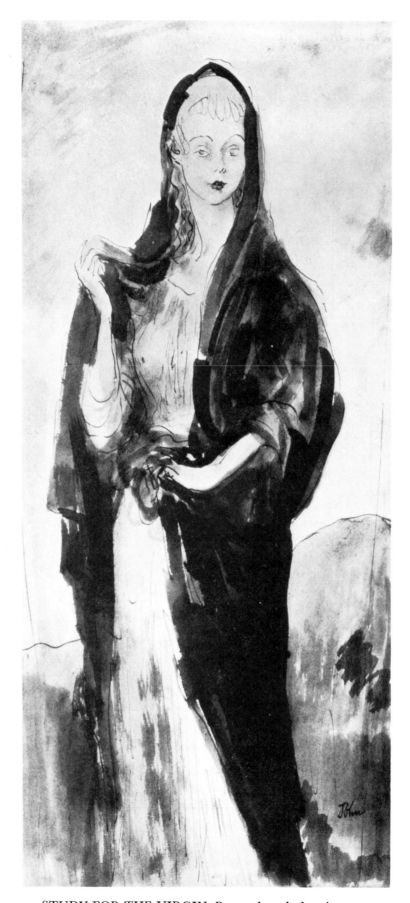

19. STUDY FOR THE VIRGIN. Pen and wash drawing

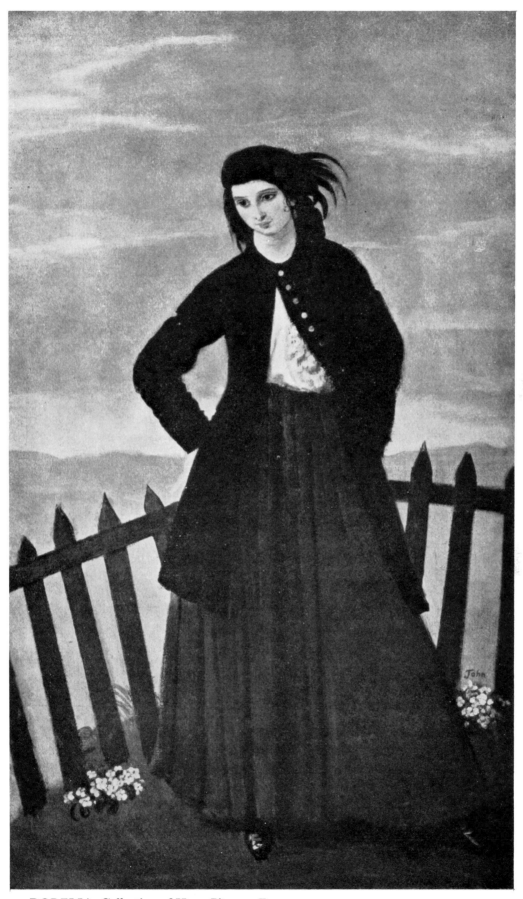

20. DORELIA. Collection of Hugo Pitman, Esq.

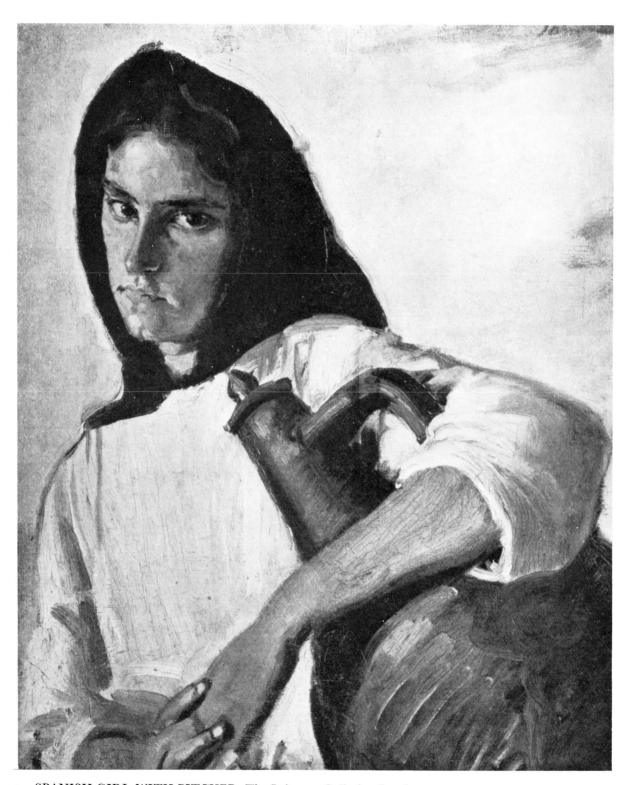

21. SPANISH GIRL WITH PITCHER. The Leicester Galleries, London

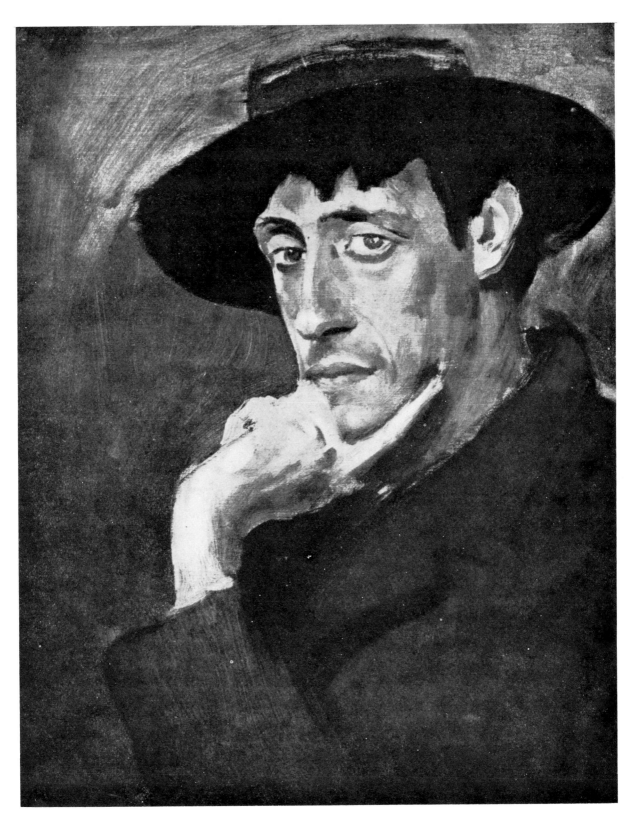

22. PORTRAIT OF AMBROSE McEVOY

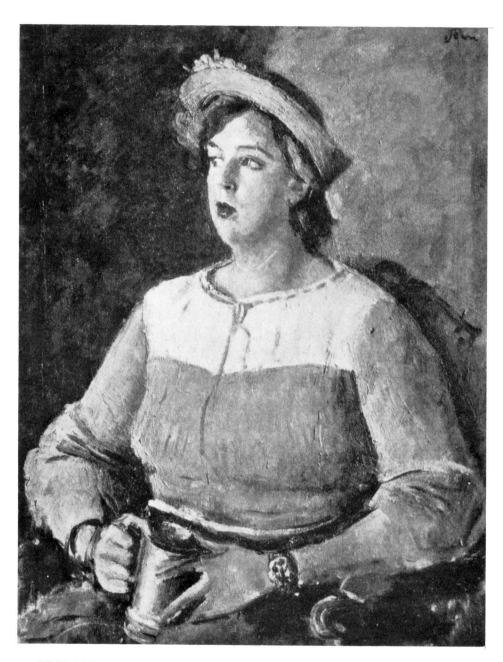

23. BRIDGIT. 1937. The Art Gallery, Southampton

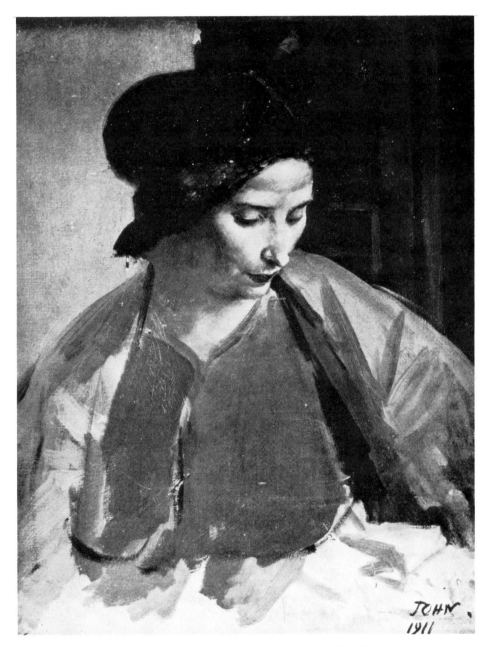

24. DORELIA. 1911. Municipal Gallery of Modern Art, Dublin

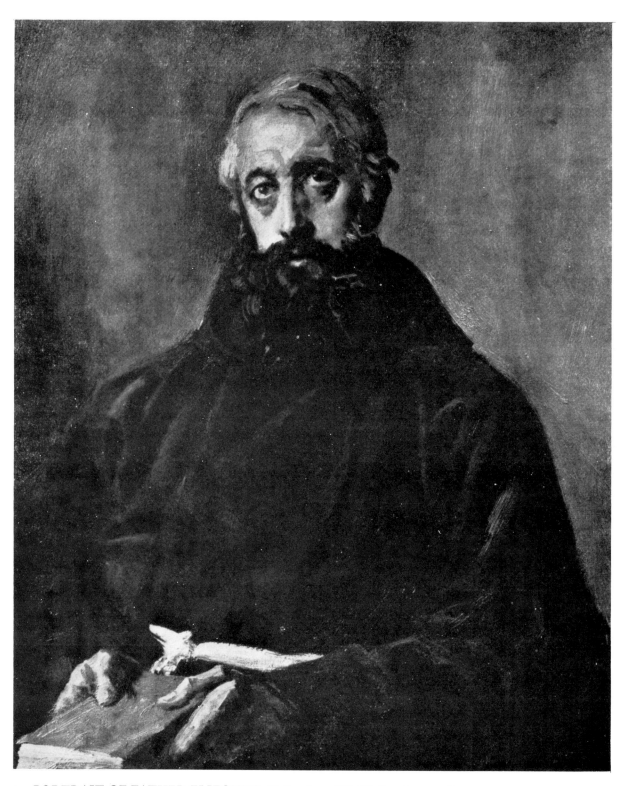

25. PORTRAIT OF FATHER ELIZONDO. Collection of F. W. Bravington, Esq.

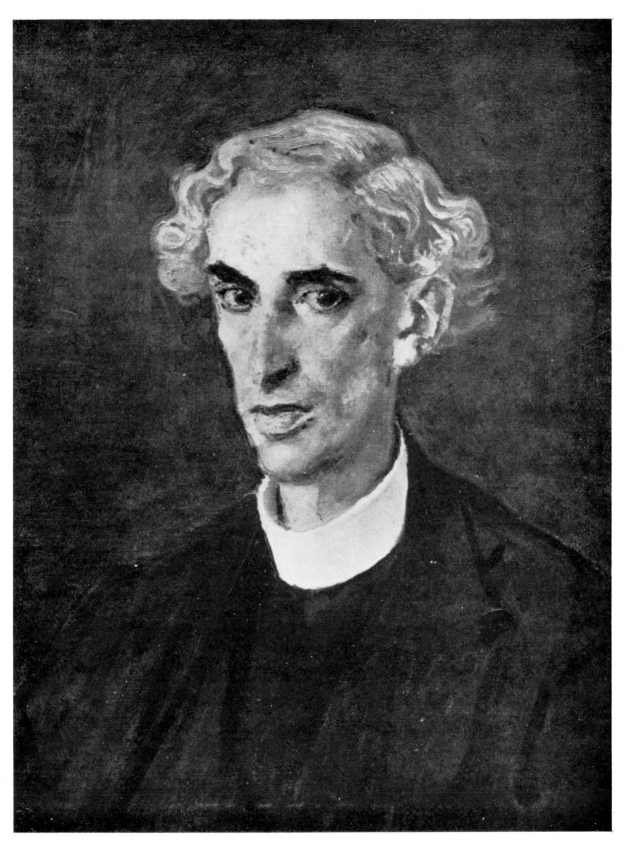

26. PORTRAIT OF THE VERY REV. M. C. D'ARCY, S.J., MASTER OF CAMPION HALL, OXFORD. 1939. Campion Hall, Oxford

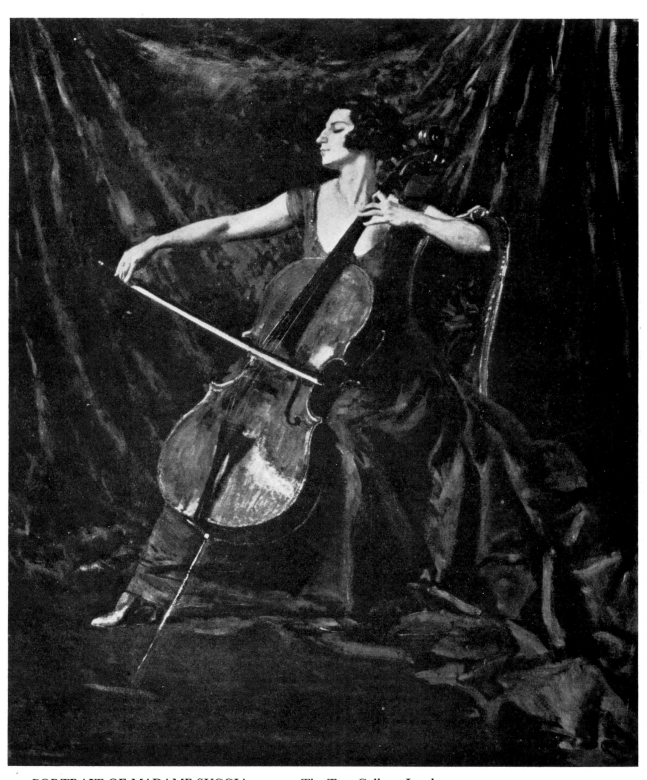

27. PORTRAIT OF MADAME SUGGIA. *c.* 1923. The Tate Gallery, London

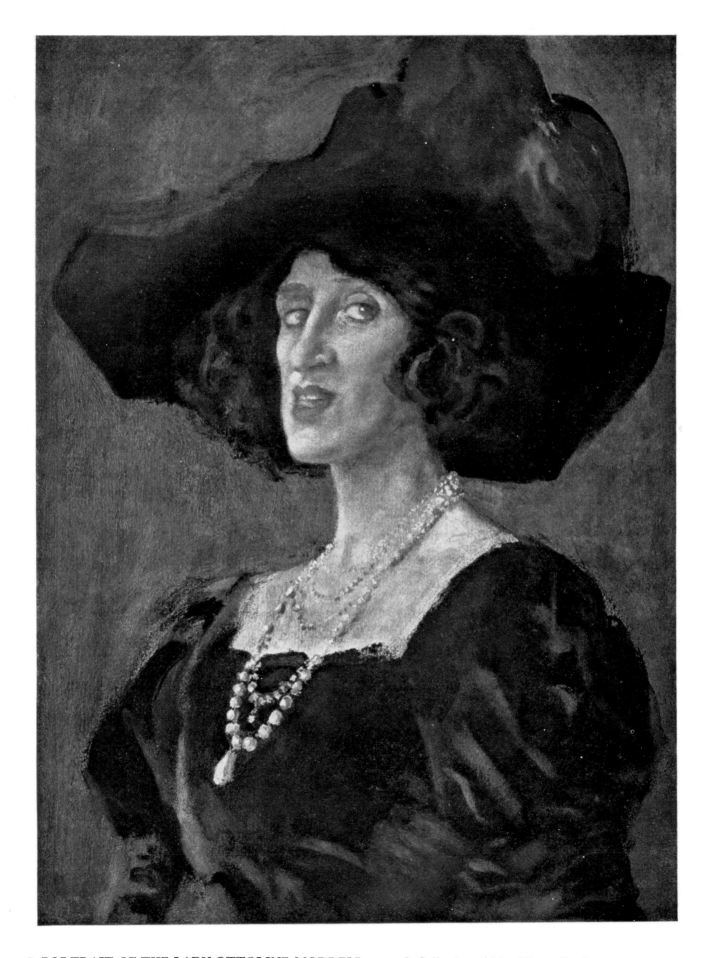

28. PORTRAIT OF THE LADY OTTOLINE MORRELL. *c.* 1926. Collection of Mrs. Victor Goodman

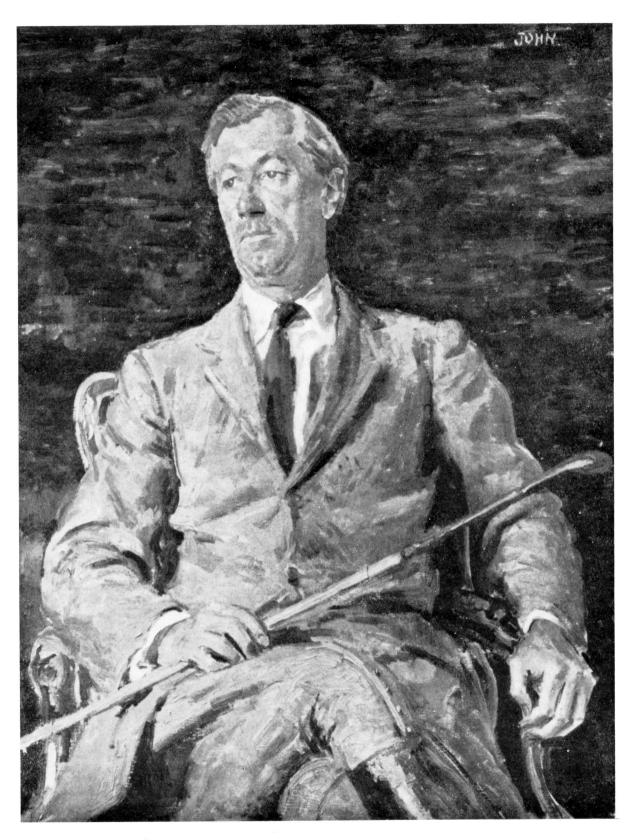

29. PORTRAIT OF Mr. J. PHIPPS. Collection of Mr. J. Phipps

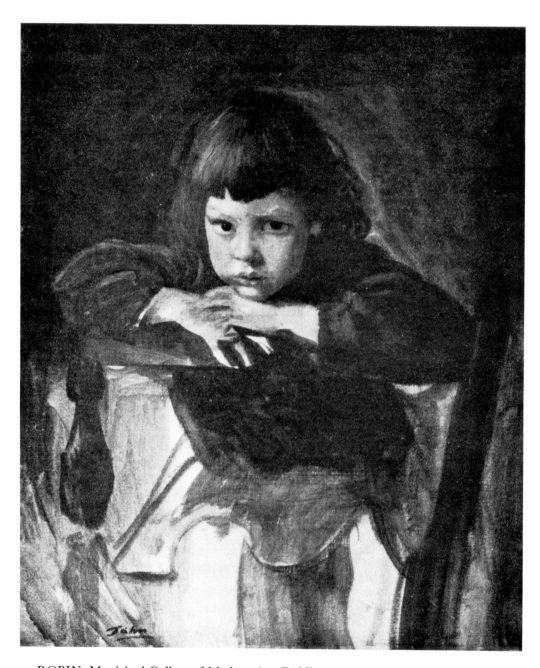

30. ROBIN. Municipal Gallery of Modern Art, Dublin

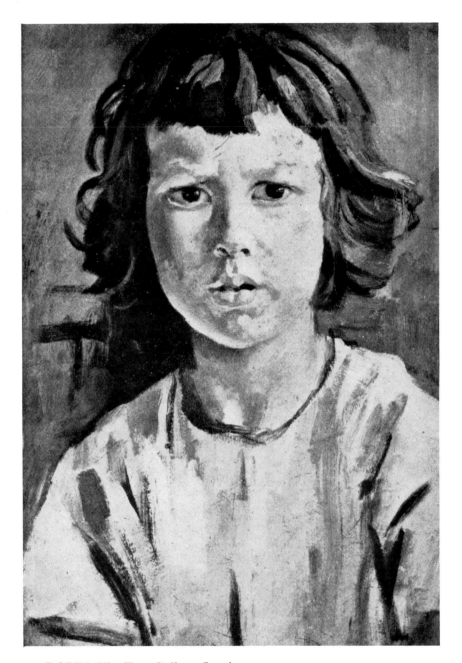

31. ROBIN. The Tate Gallery, London

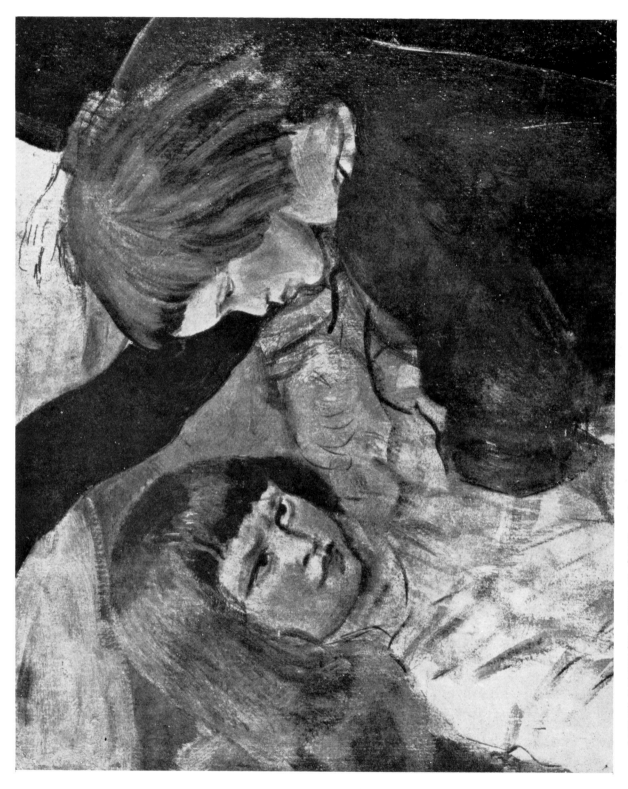

32. LYRIC FANTASY, DETAIL OF No. 78

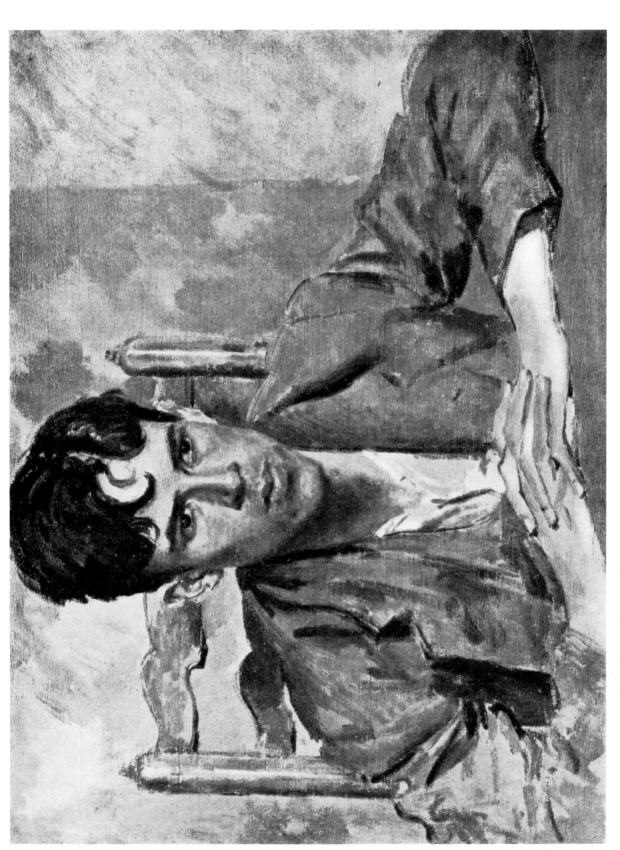

33. DAVID. Collection of A. Chester Beatty, Esq.

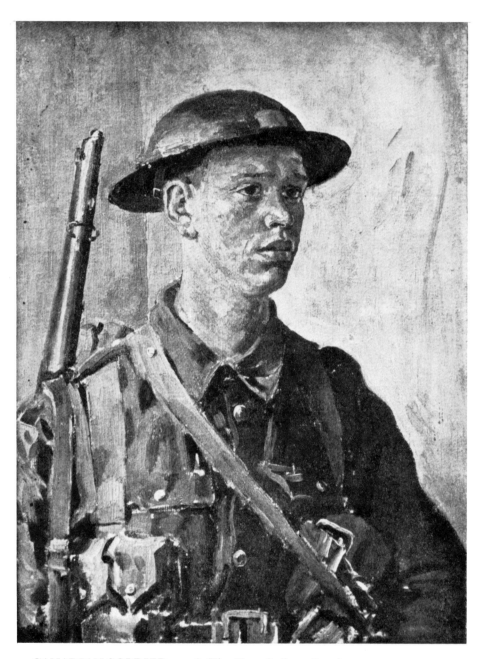

34. CANADIAN SOLDIER. 1918. The Tate Gallery, London

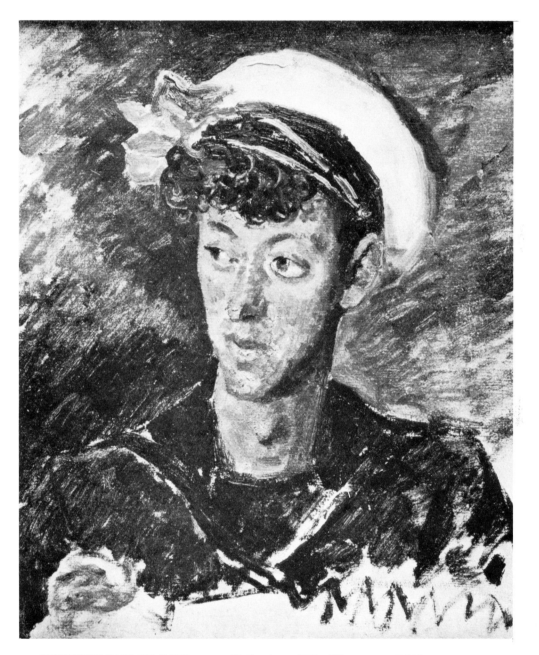

35. CORNISH SAILOR BOY. 1937. Collection of The Viscountess D'Abernon

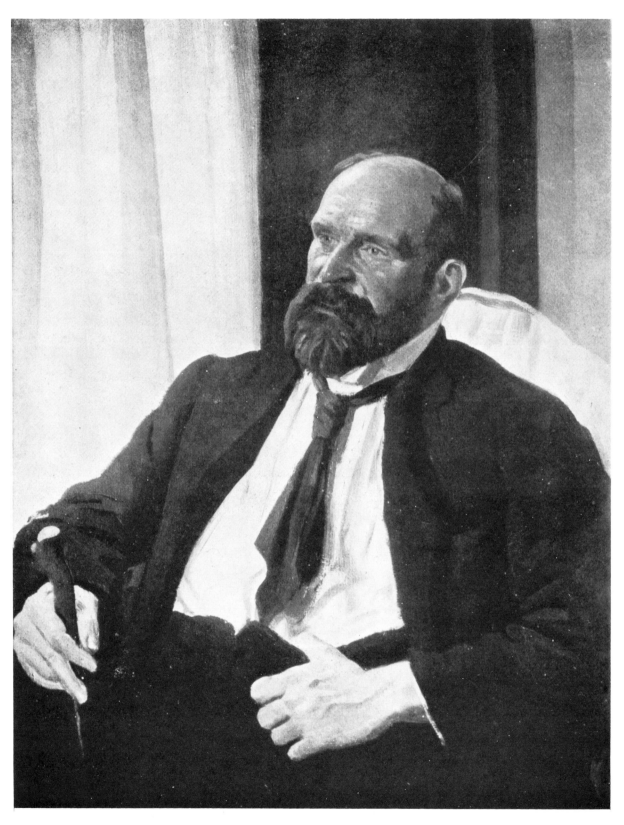

36. PORTRAIT OF KUNO MEYER. *c.* 1911. By permission of the Board of Governors and Guardians of the National Gallery of Ireland, Dublin

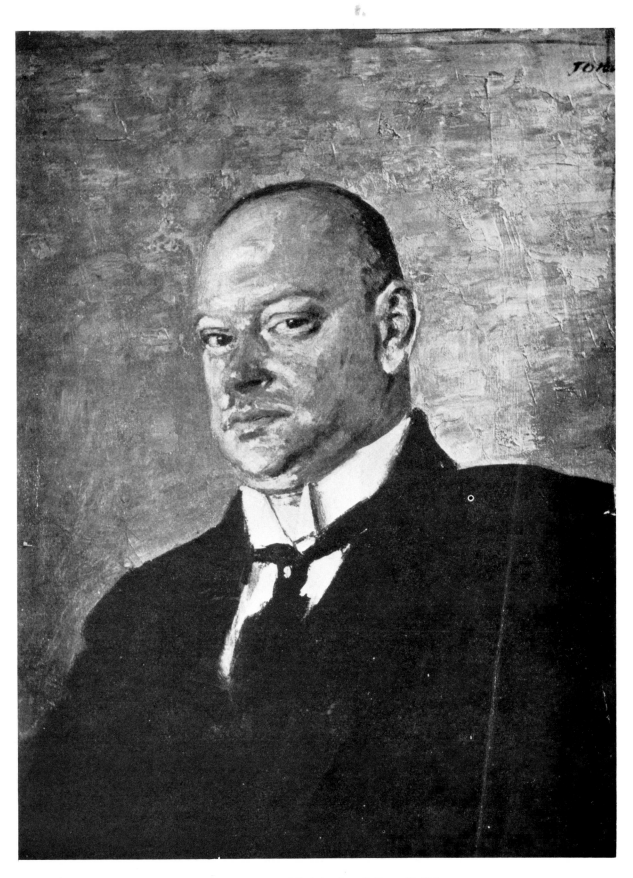

37. PORTRAIT OF STRESEMANN. *c.* 1924. Albright Art Gallery, Buffalo

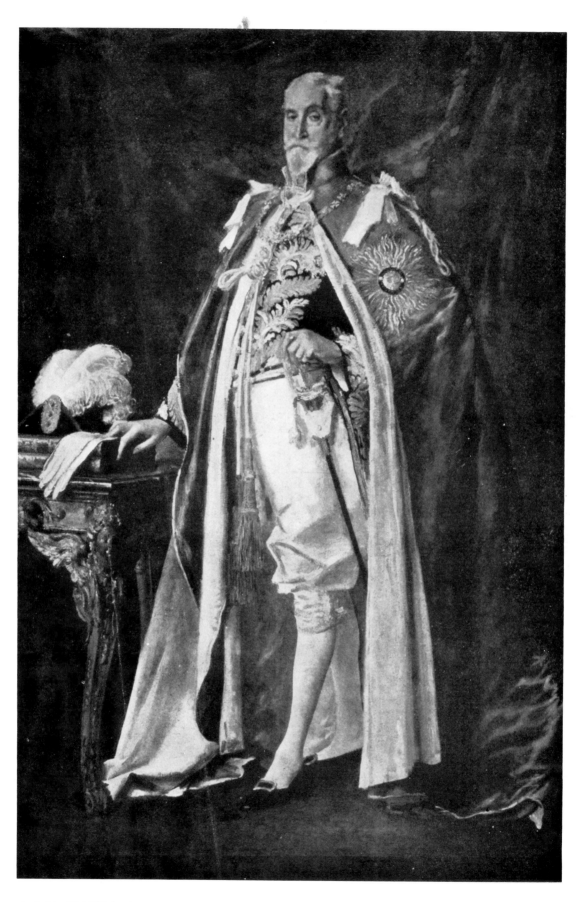

38. PORTRAIT OF THE LATE VISCOUNT D'ABERNON. 1931. Collection of The Viscountess D'Abernon

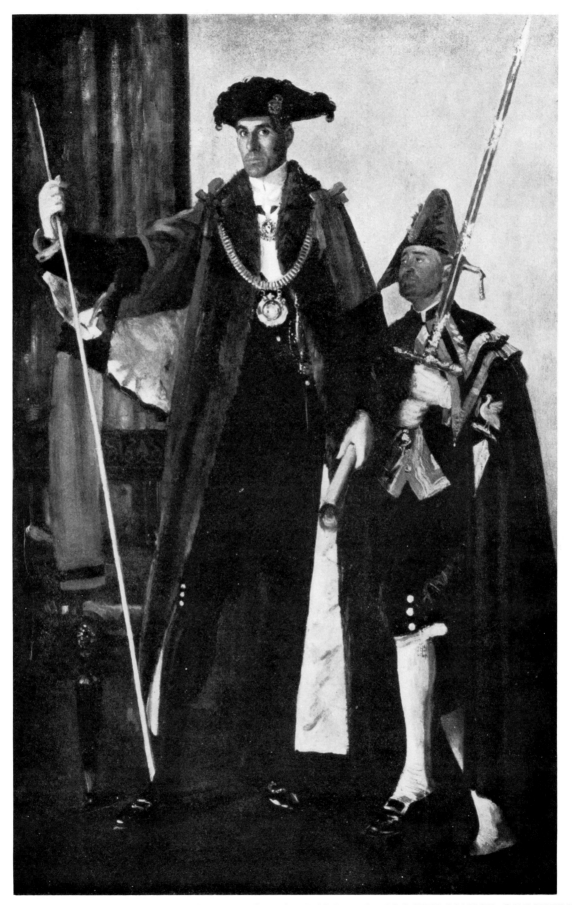

39. PORTRAIT OF HIS HONOUR H. C. DOWDALL, K.C., AS LORD MAYOR OF LIVERPOOL.
1908–9. National Gallery of Victoria, Melbourne

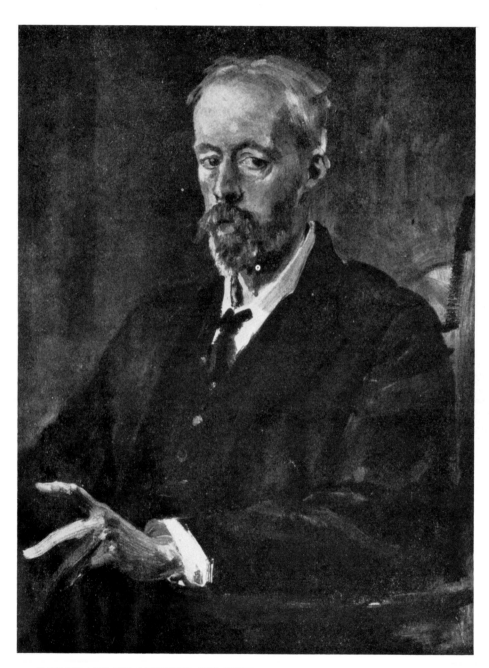

40. PORTRAIT OF ARTHUR SYMONS. *c.* 1917

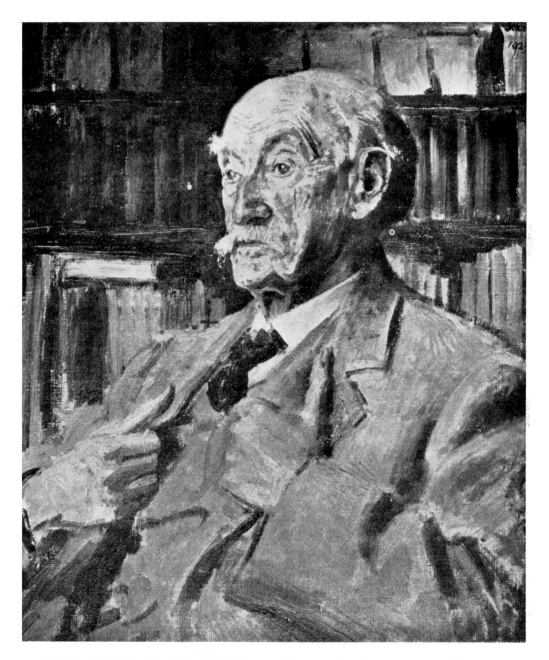

41. PORTRAIT OF THOMAS HARDY, O.M. 1923. Fitzwilliam Museum, Cambridge

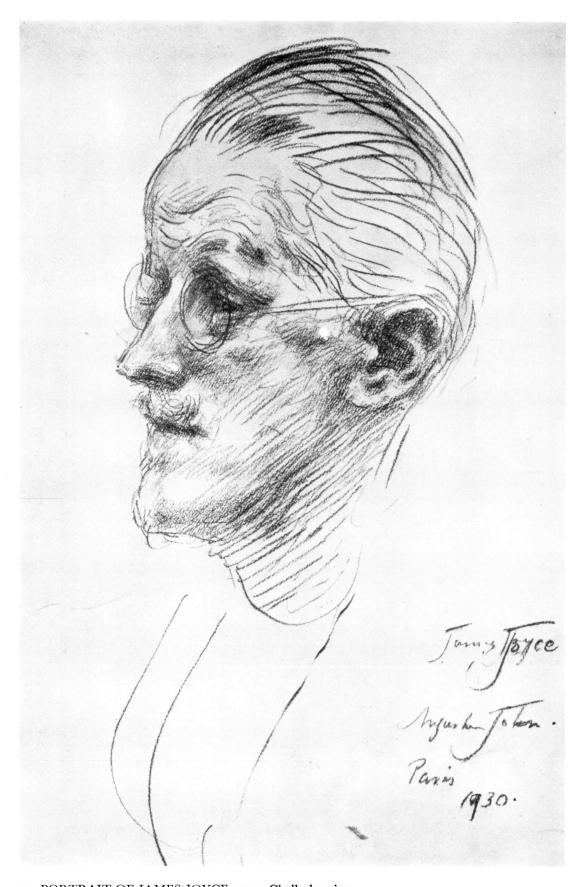

42. PORTRAIT OF JAMES JOYCE. 1930. Chalk drawing

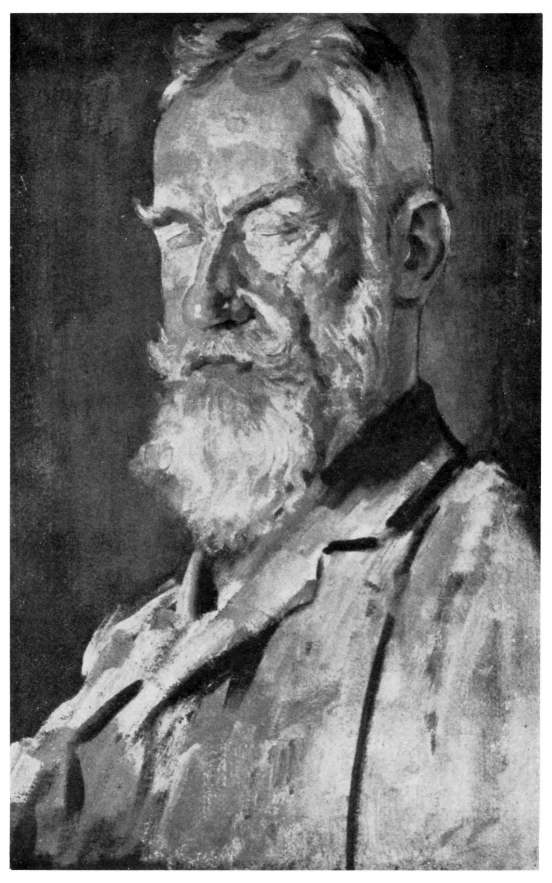

43. PORTRAIT OF GEORGE BERNARD SHAW. *c.* 1914. Reproduced by gracious permission of H.M. The Queen

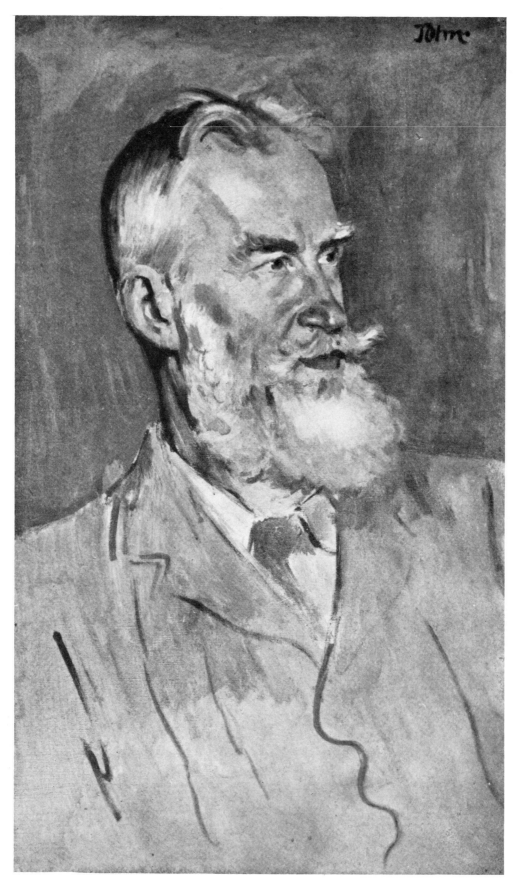

44. PORTRAIT OF GEORGE BERNARD SHAW. *c.* 1914. Fitzwilliam Museum, Cambridge

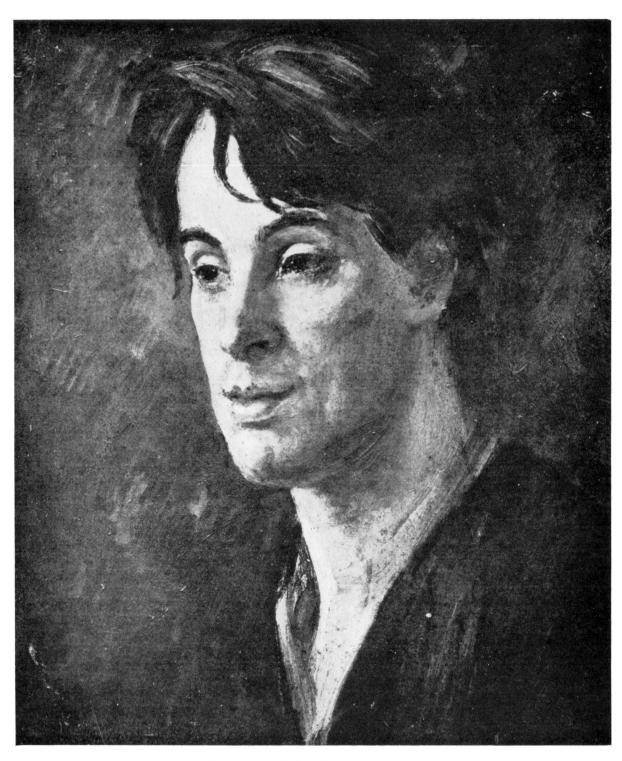

45. PORTRAIT OF W. B. YEATS. The Tate Gallery, London

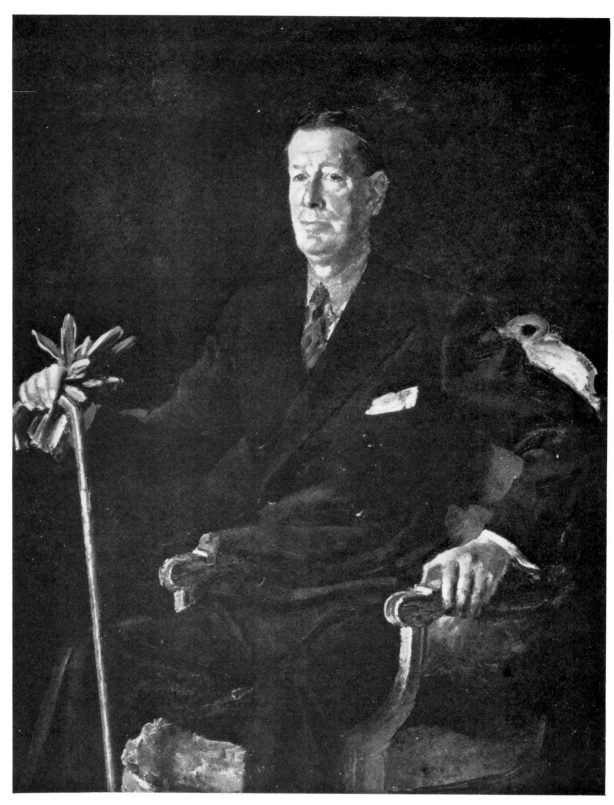

46. PORTRAIT OF THOMAS BARCLAY. 1933. Collection of J. I. M. Barclay, Esq.

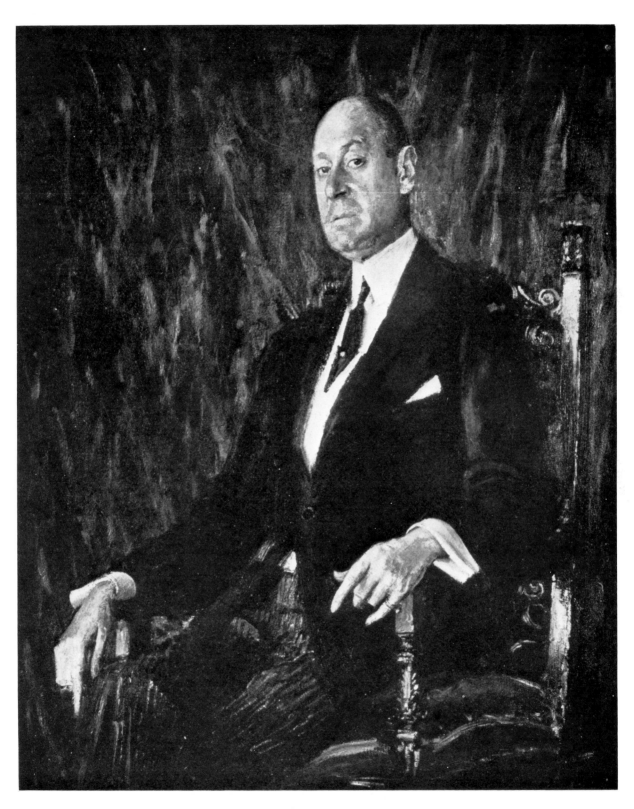

47. PORTRAIT OF JOSEPH WIDENER. National Gallery of Art, Washington

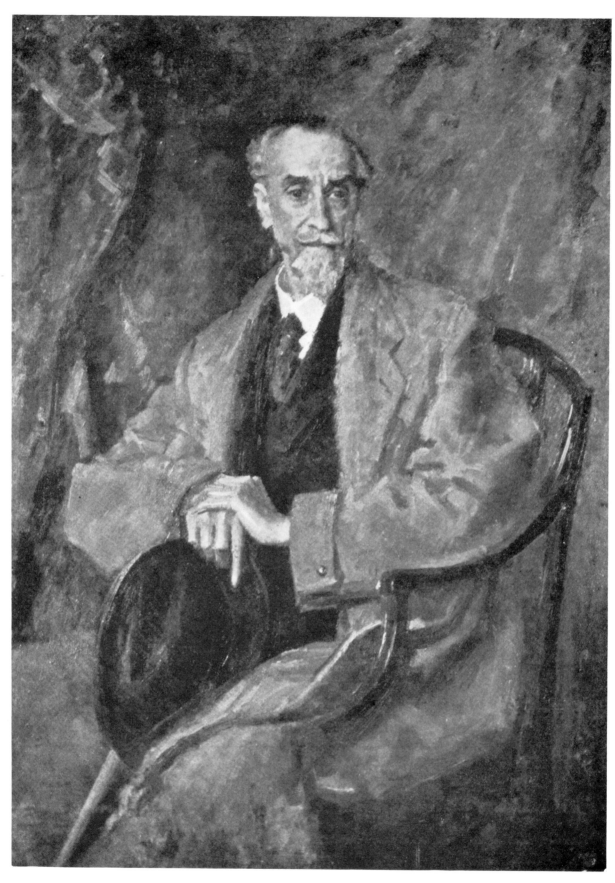

48. PORTRAIT OF THE RT. HON. MONTAGU NORMAN, P.C. The Bank of England

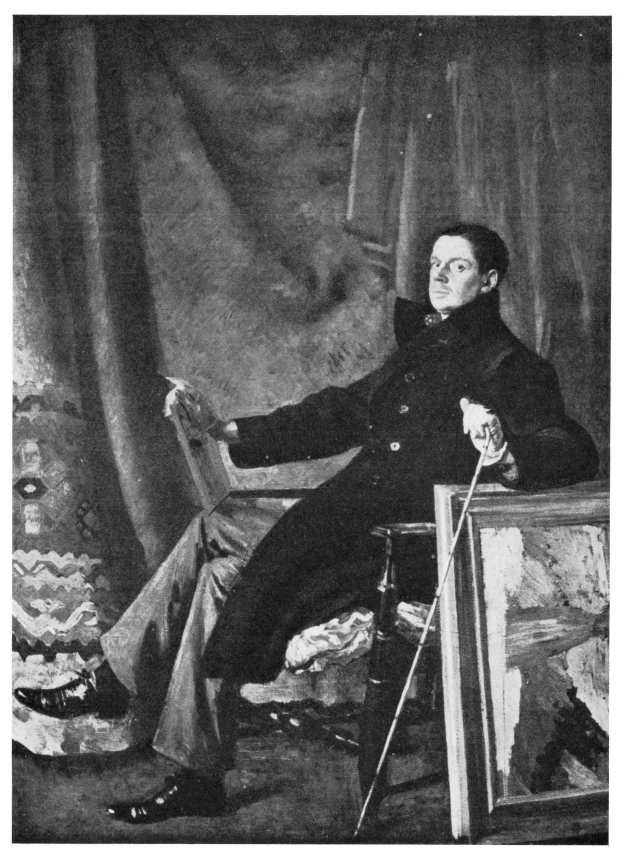

49. PORTRAIT OF WILLIAM NICHOLSON. Fitzwilliam Museum, Cambridge

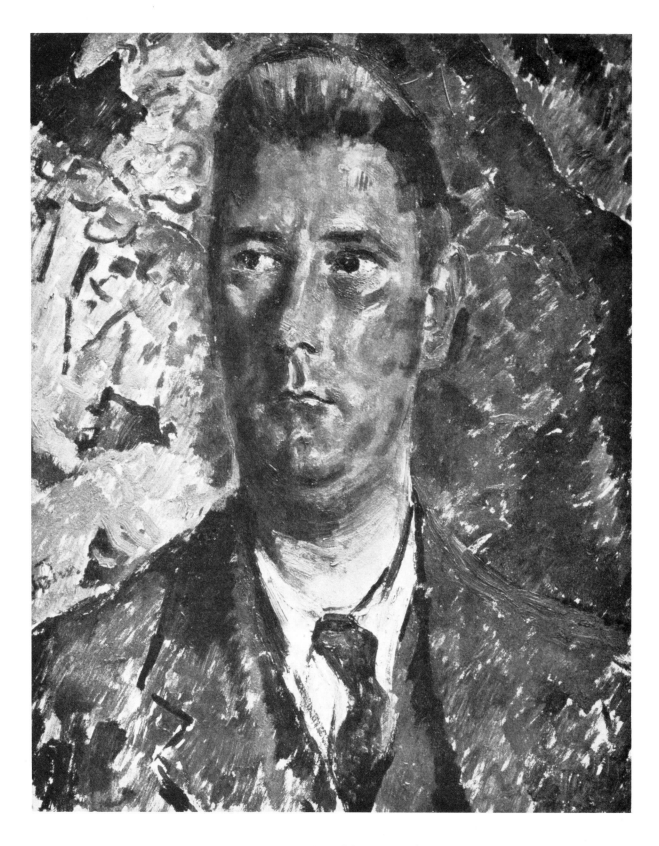

50. PORTRAIT OF T. W. EARP. *c.* 1926. Collection of Captain Philip Dunn

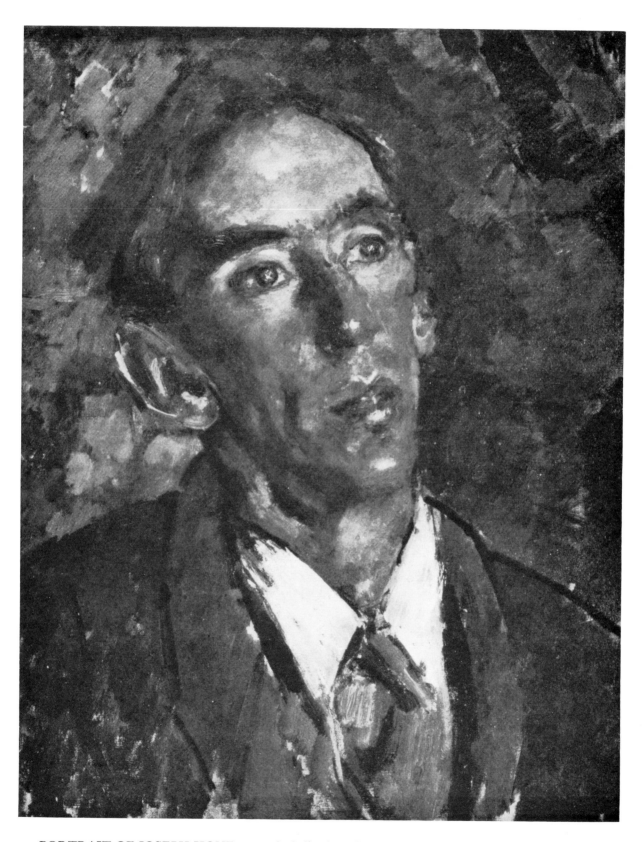

51. PORTRAIT OF JOSEPH HONE. *c.* 1926. Collection of Flight Lieut. C. W. Adams

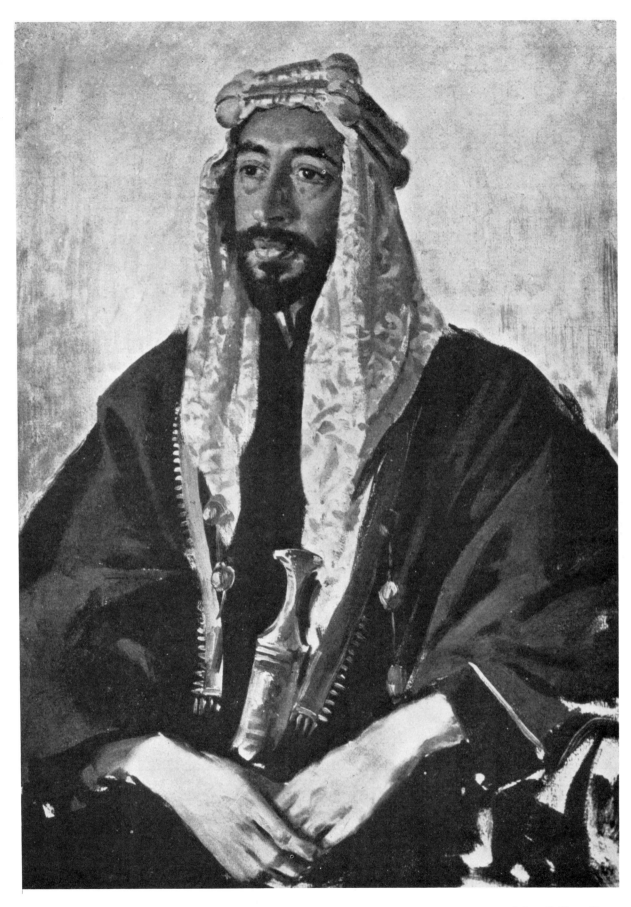

52. PORTRAIT OF THE EMIR FEISAL. 1919. By permission of the City Museum and Art Gallery Committee of the Corporation of Birmingham

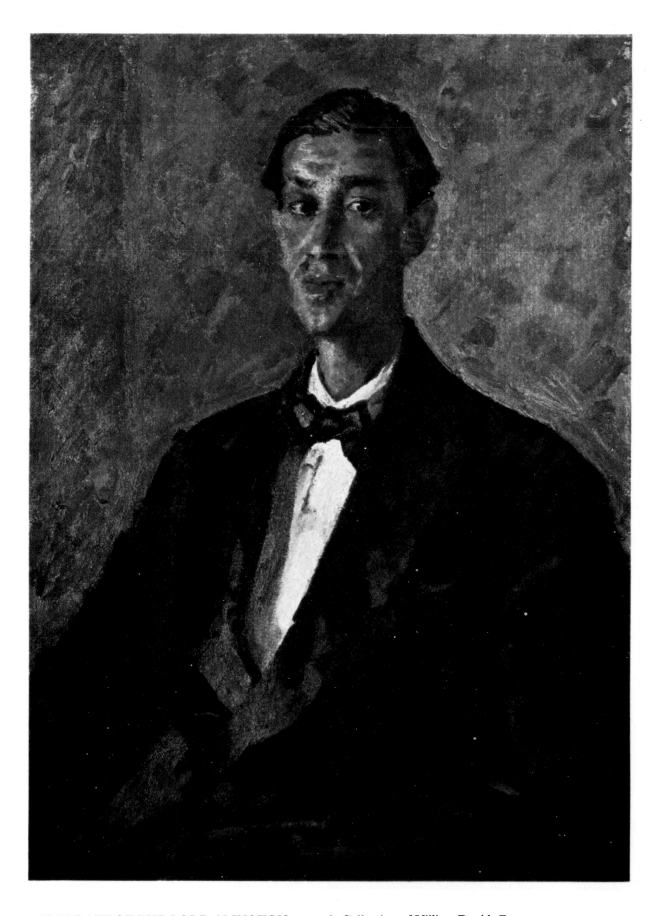

53. PORTRAIT OF THE LORD ALINGTON. *c.* 1938. Collection of Villiers David, Esq.

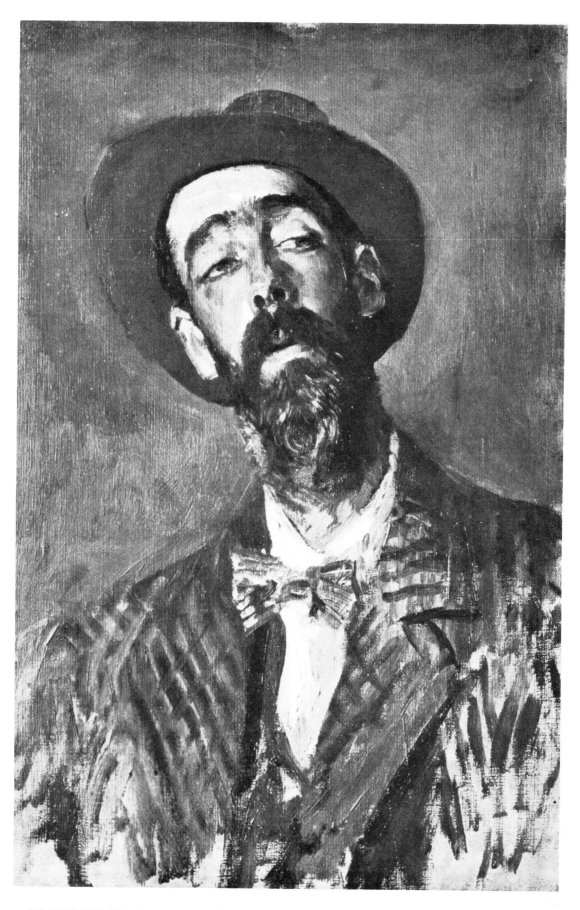

54. PORTRAIT OF TRELAWNAY DAYRELL REED. Collection of Stevenson Scott, Esq.

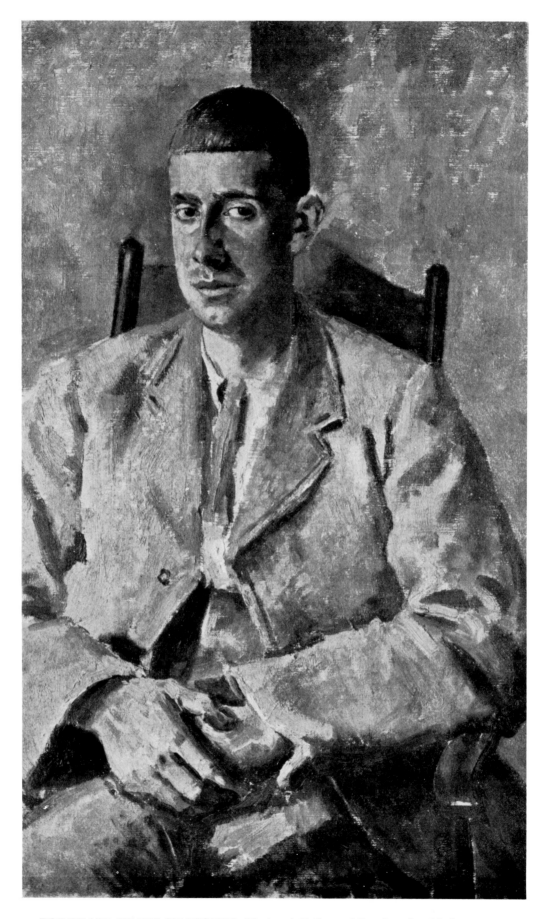

55. PORTRAIT OF PERCY USSHER. National Gallery of Sweden, Stockholm

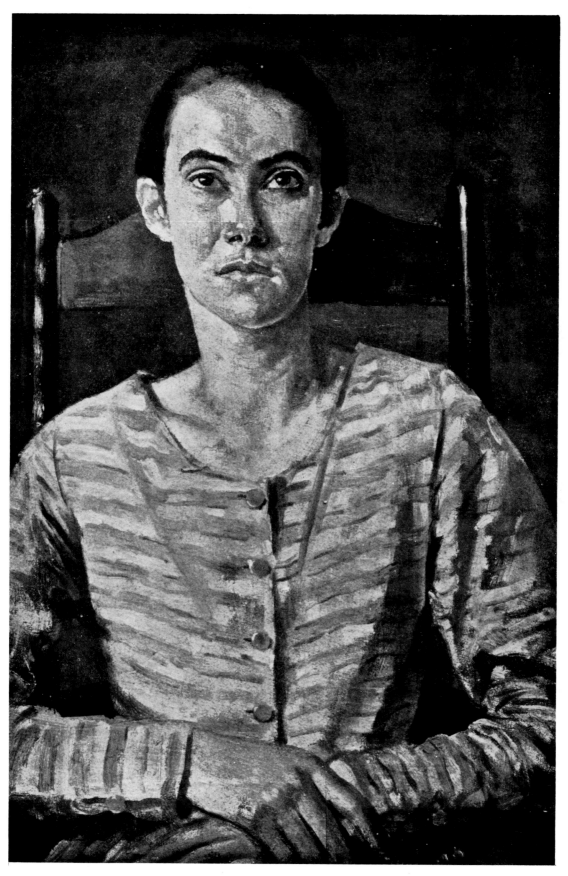

56. PORTRAIT OF MISS FANNY FLETCHER. Japanese private collection

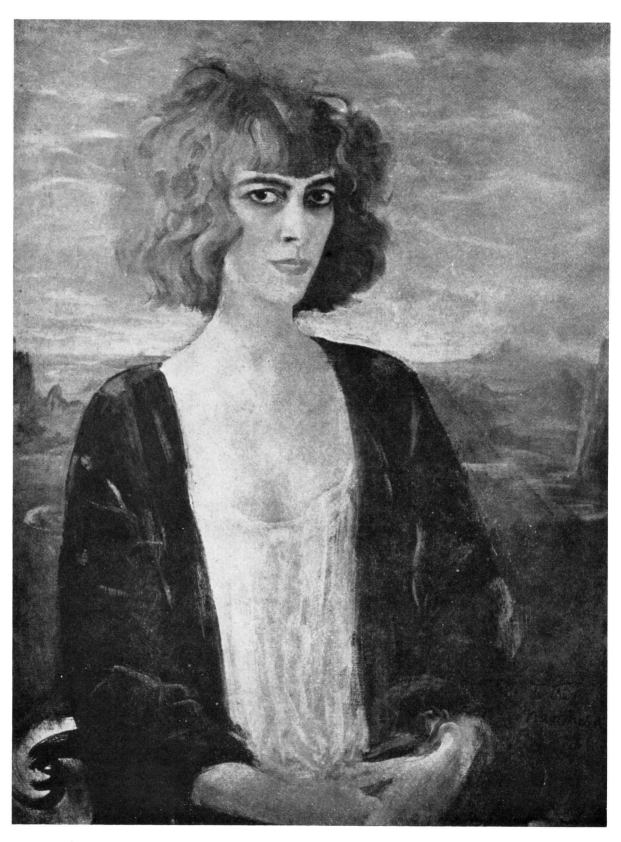

57. PORTRAIT OF THE MARCHESA CASATI. 1919. Collection of The Hon. Mary Sturt

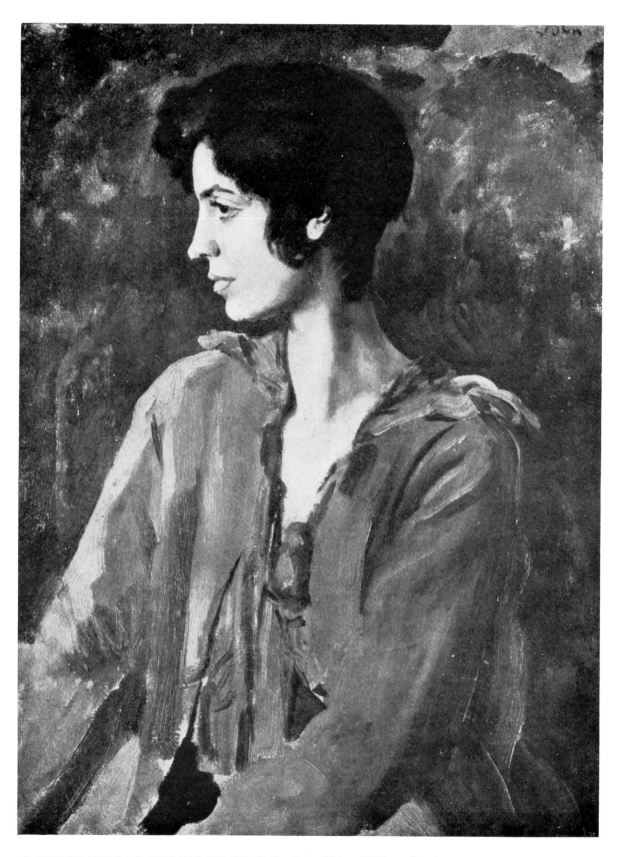

58. PORTRAIT OF LADY PALAIRET. Collection of Mrs. William Cazalet

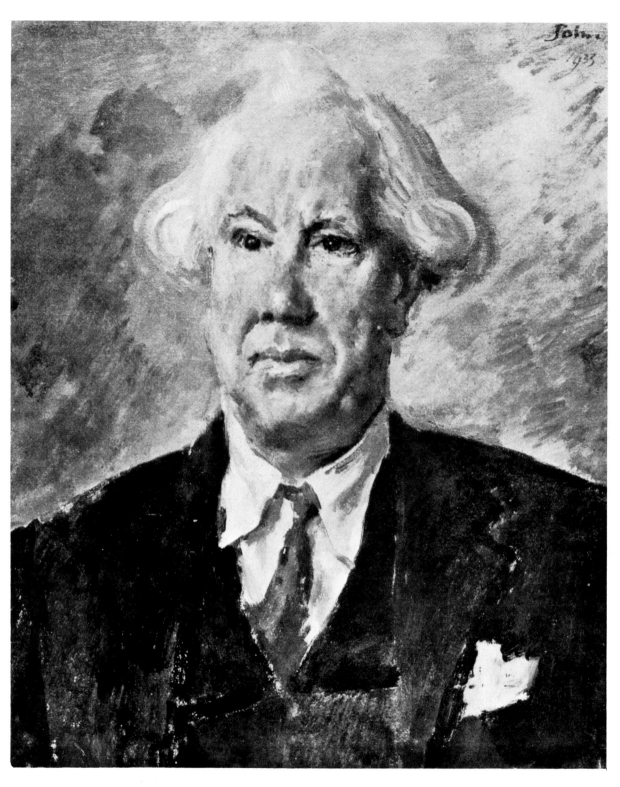

59. PORTRAIT OF WILLIAM McELROY. 1933

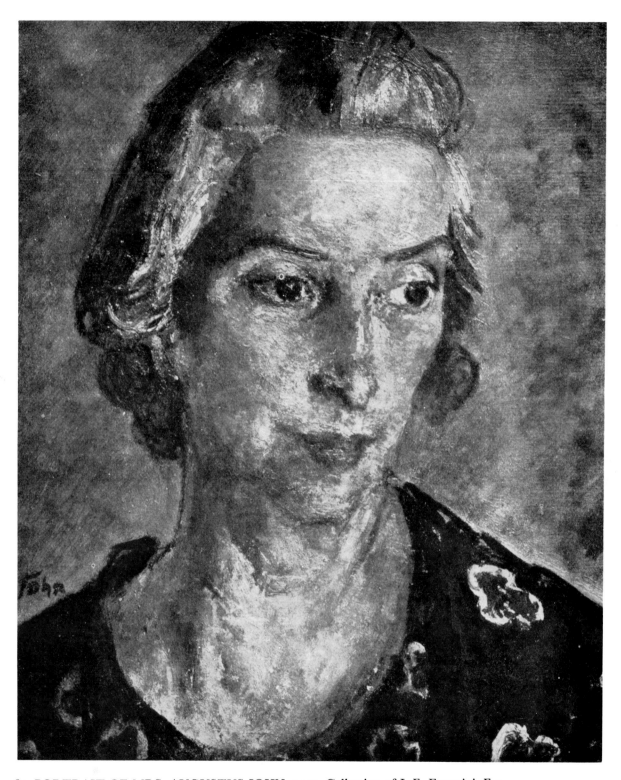

60. PORTRAIT OF MRS. AUGUSTUS JOHN. 1937. Collection of J. E. Fattorini, Esq.

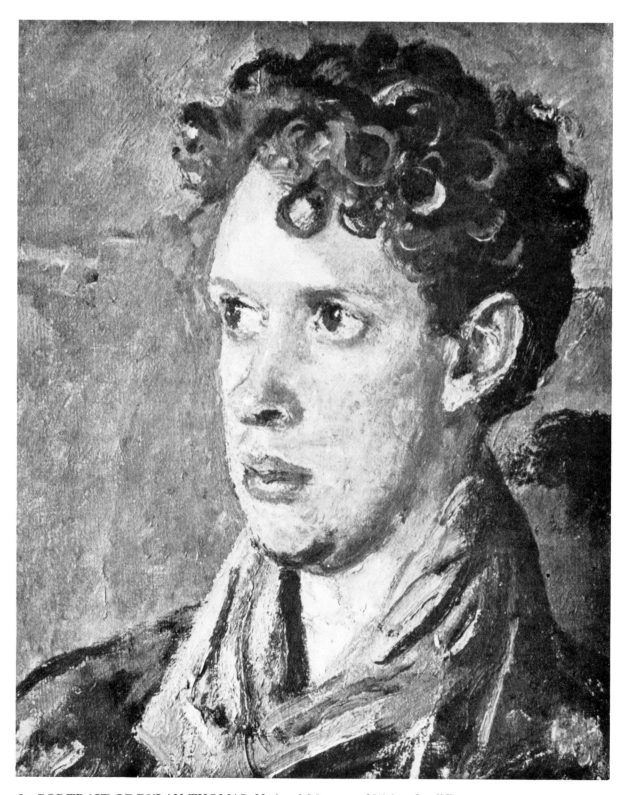

61. PORTRAIT OF DYLAN THOMAS. National Museum of Wales, Cardiff

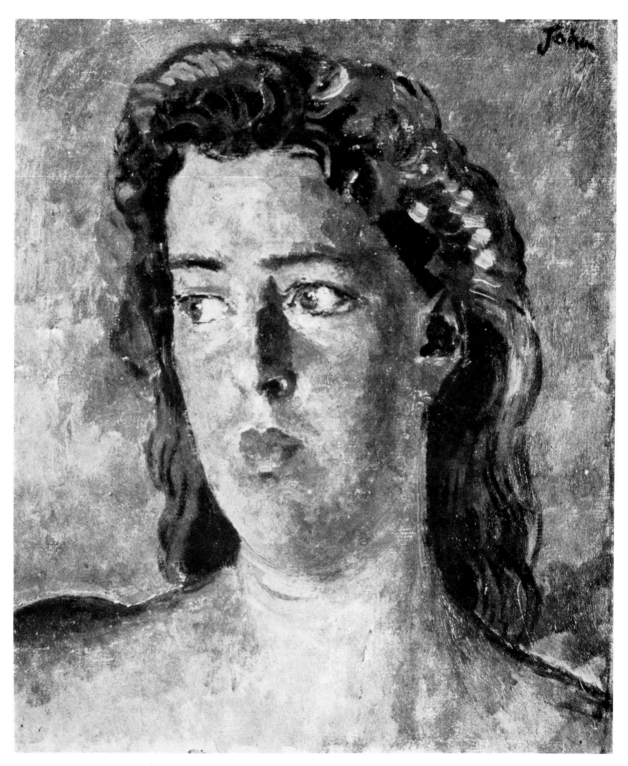

62. BRIDGIT. 1937. Collection of the Artist

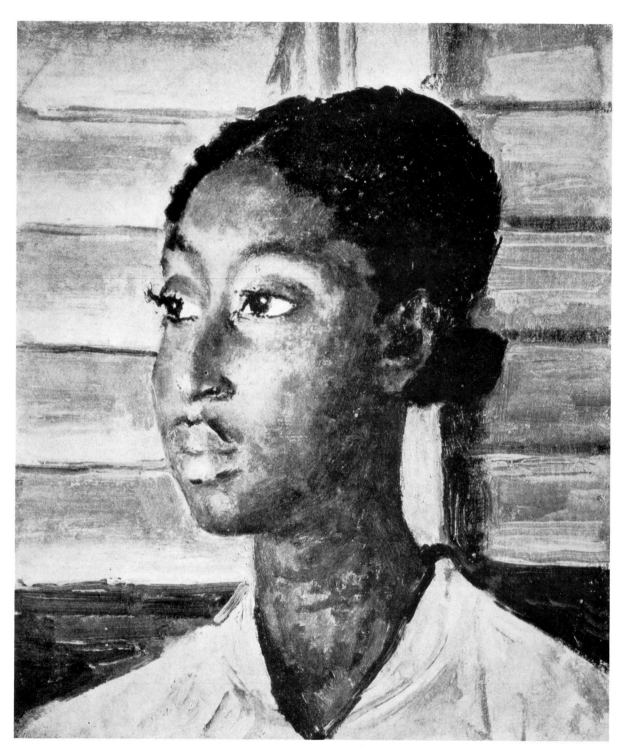

63. DAPHNE. 1937. Collection of Lady Mary Dunn

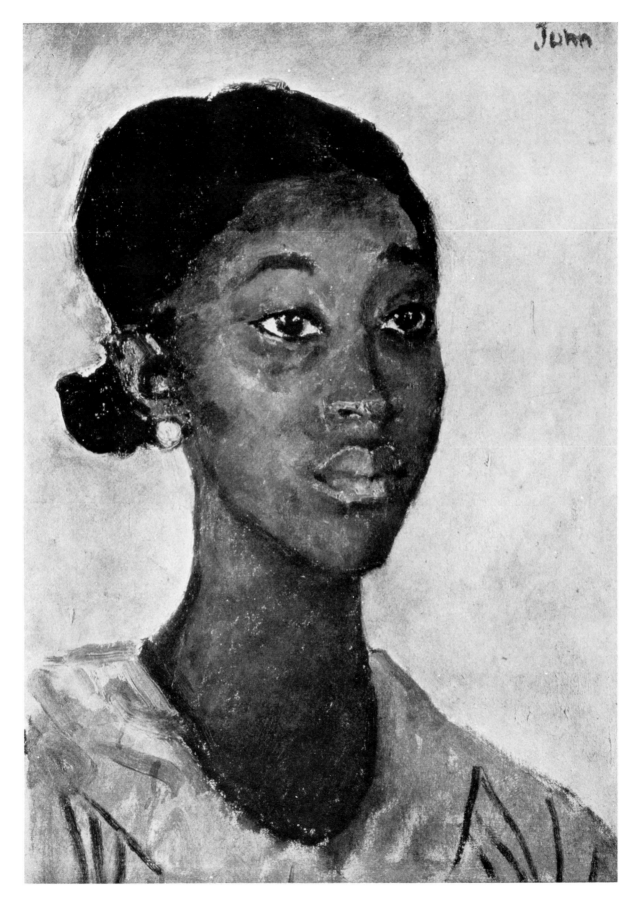

64. PHYLLIS. 1937. Collection of H. R. Gough, Esq.

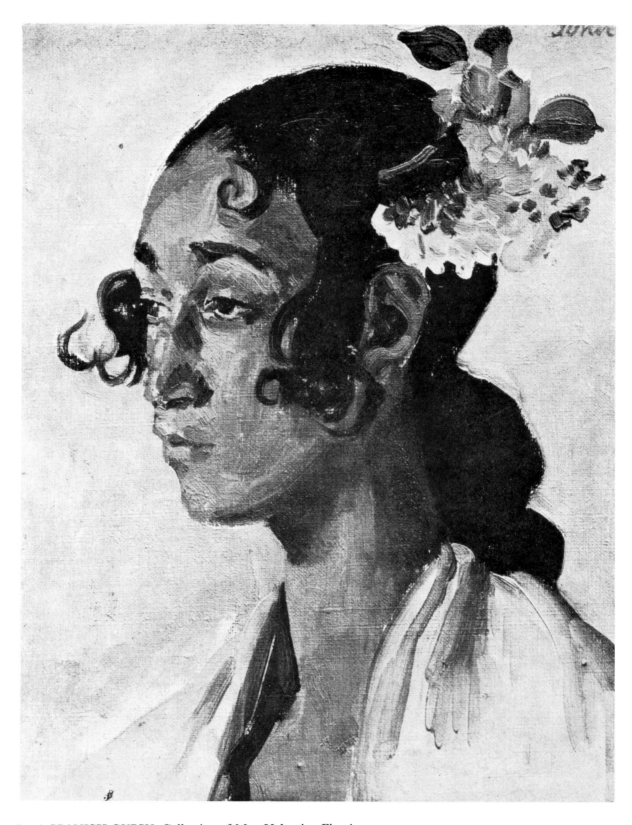

65. A SPANISH GYPSY. Collection of Mrs. Valentine Fleming

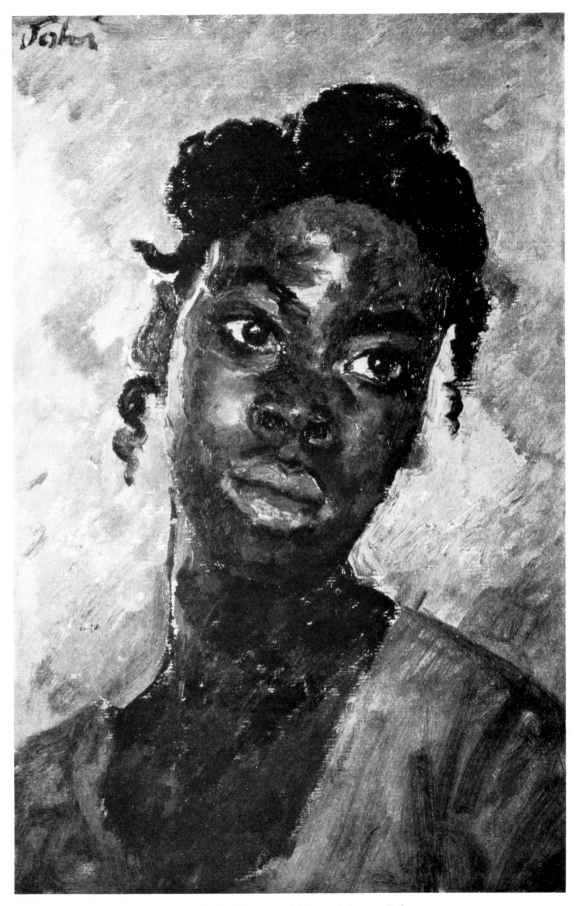

66. AMINTA. 1937. Collection of The Rt. Hon. Vincent Massey, P.C.

67. ODD WOMEN. Pen and Wash Drawing. Collection of Mrs. Valentine Fleming

68. 'ATQUE IN ARCADIA EGO . . .' Chalk Drawing

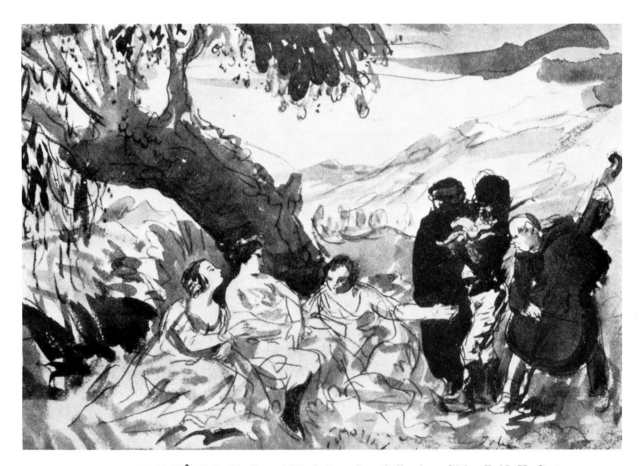

69. LE CONCERT CHAMPÊTRE. Chalk and Wash Drawing. Collection of Mrs. F. H. K. Green

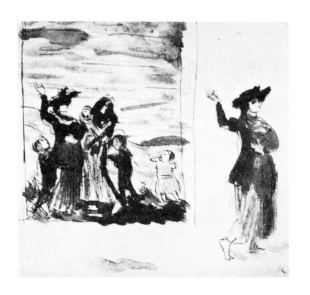
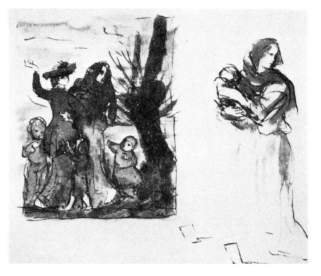
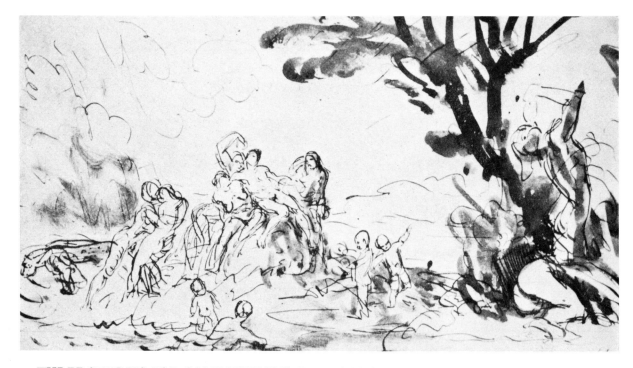

70. THREE STUDIES FOR COMPOSITIONS. Pen and Wash Drawings

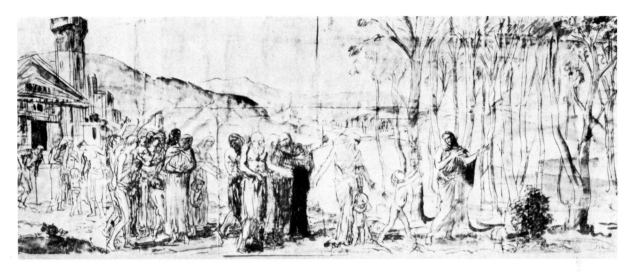

71. ALCESTIS. Pen, Chalk and Wash Drawing. Collection of Mrs. Valentine Fleming

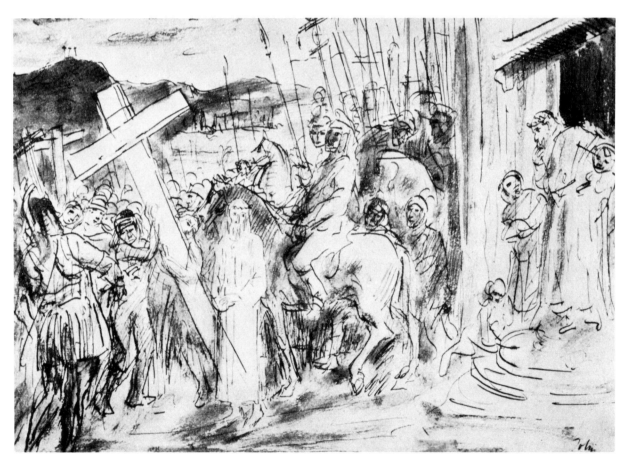

72. THE ROAD TO CALVARY. Chalk, Pen and Wash Drawing

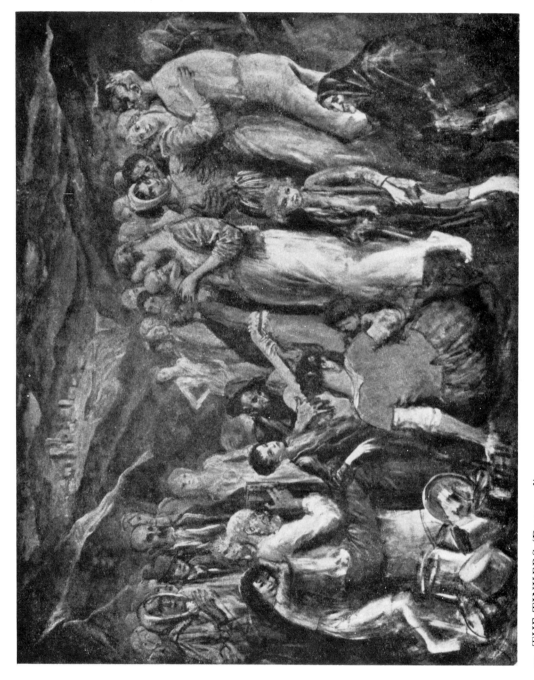

73. THE TINKERS (Destroyed)

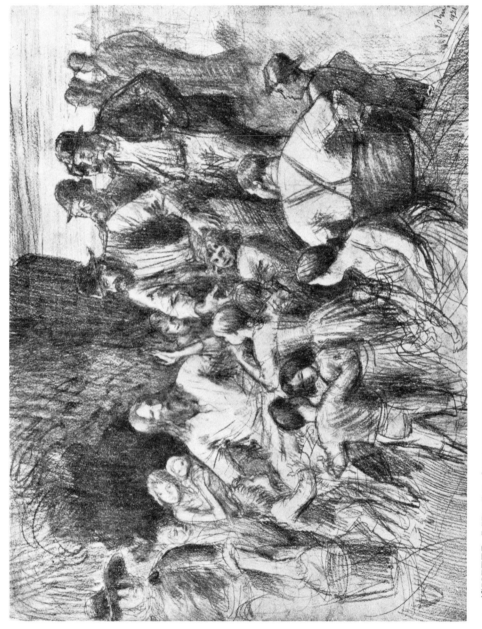

74. 'SUFFER LITTLE CHILDREN TO COME UNTO ME'. Chalk Drawing. 1921. Collection of Mrs. Valentine Fleming

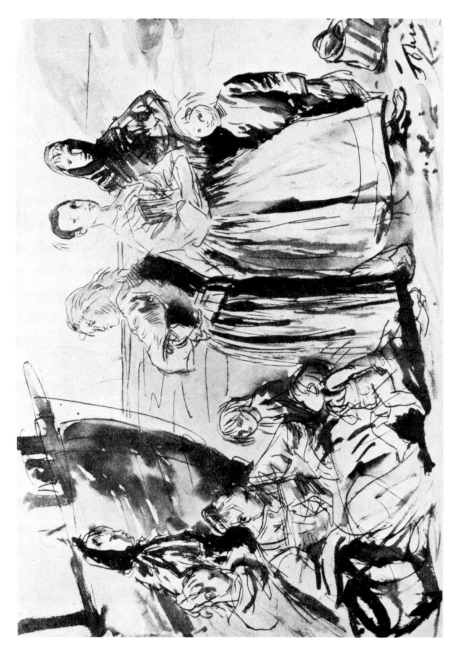

75. GROUP BY THE SEASHORE: EQUIHEN FISHERGIRLS. *c.* 1900. Pen and Wash Drawing.
Collection of H. C. Laurence, Esq.

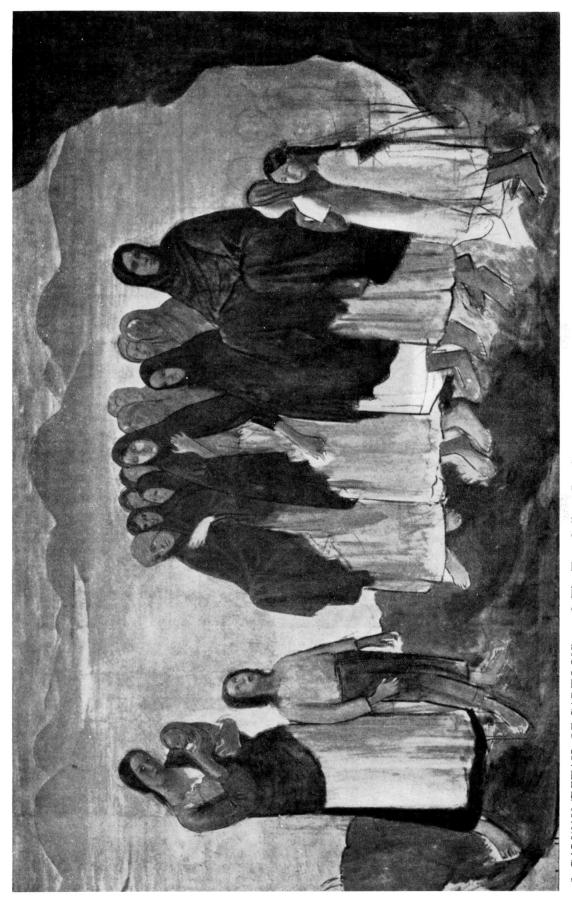

76. GALWAY (DETAIL OF CARTOON). 1916. The Tate Gallery, London

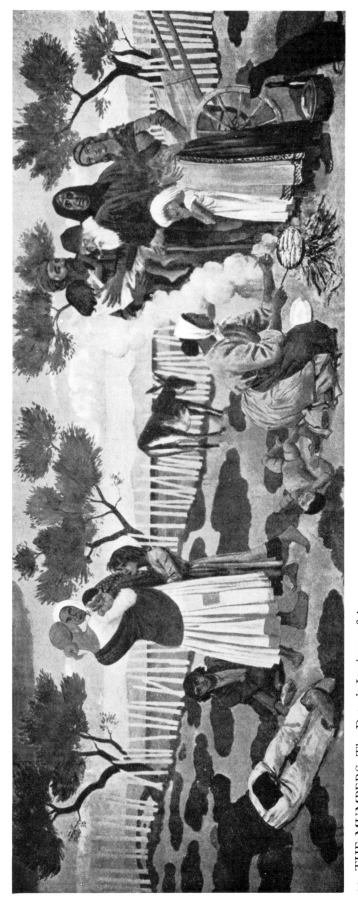

77. THE MUMPERS. The Detroit Institute of Arts

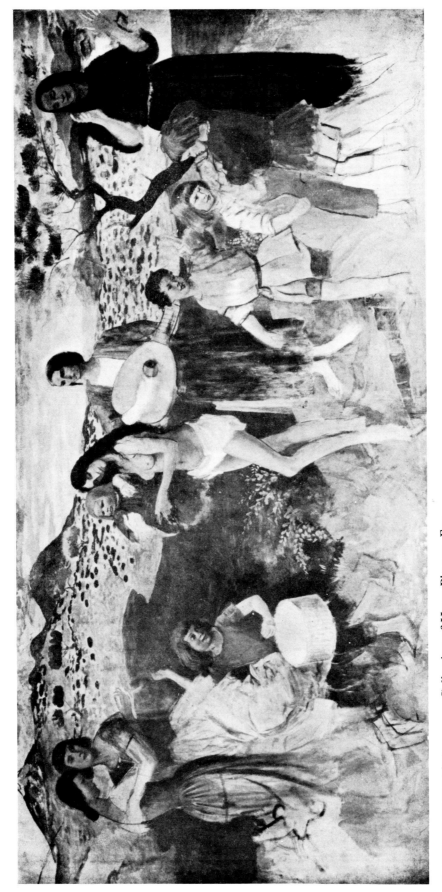

78. LYRIC FANTASY. *c.* 1911. Collection of Hugo Pitman, Esq.

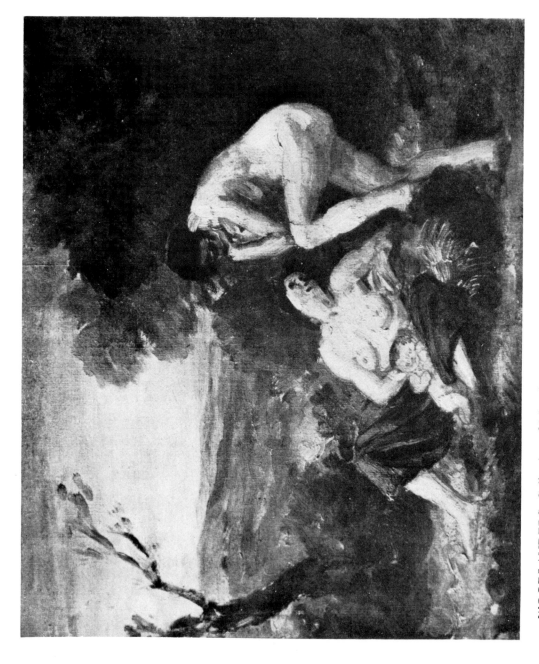

79. WOODLANDERS. Collection of Mrs. Augustus John

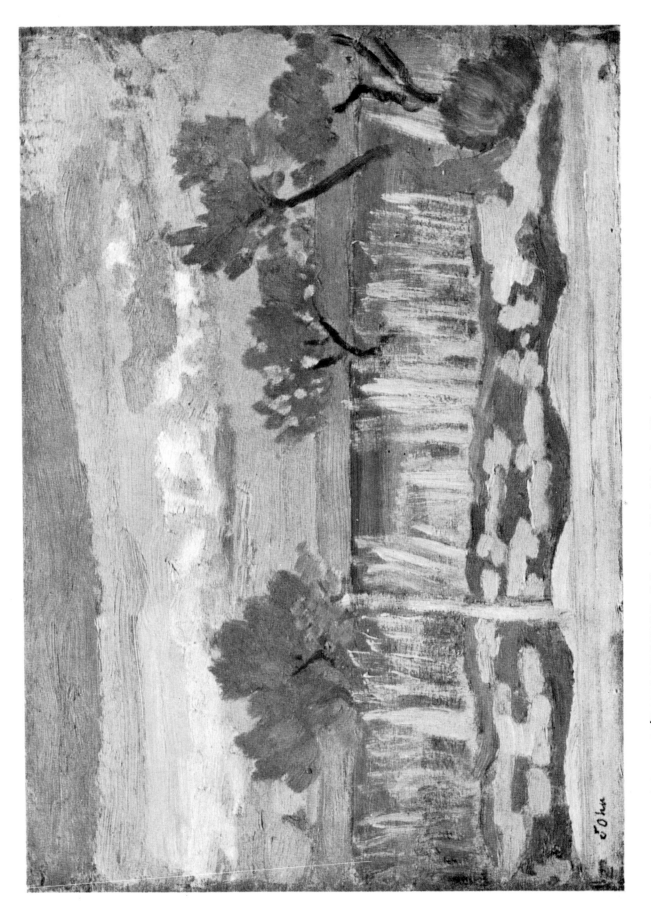

80. OLIVE TREES BY THE ÉTANG DE BERRE. Collection of Mrs. Valentine Fleming

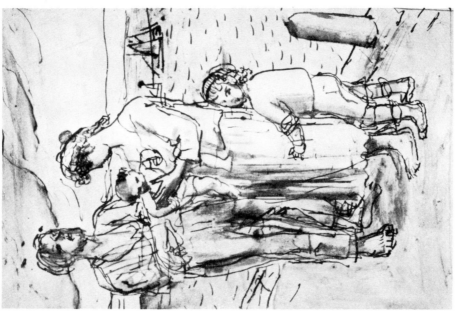

82. FISHERMAN'S FAMILY. Pen and Wash Drawing

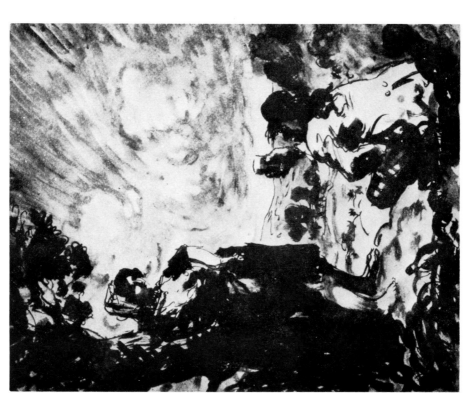

81. ILLUSTRATION TO 'OMAR'. Pen and Wash Drawing.
Collection of the late Sir Michael Sadler

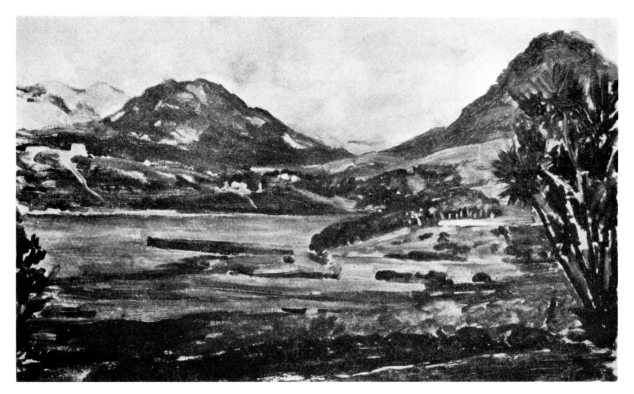

83. CONNEMARA

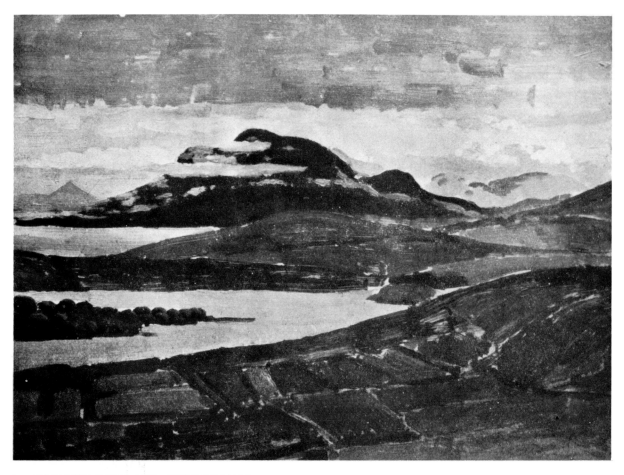

84. CROAGH PADRAIG, CONNEMARA

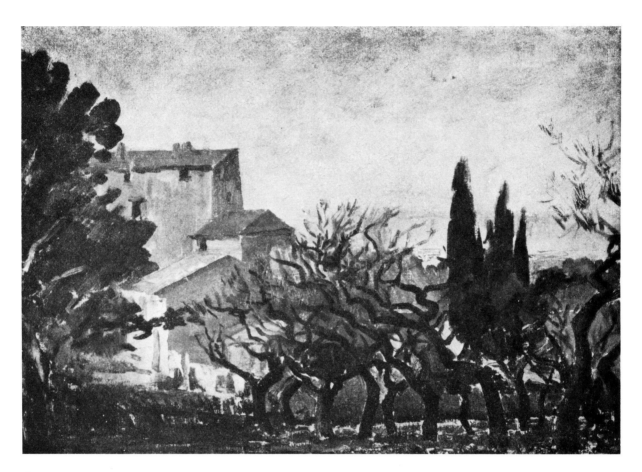

85. CHATEAU NEUF, PROVENCE. Collection of J. E. Fattorini, Esq.

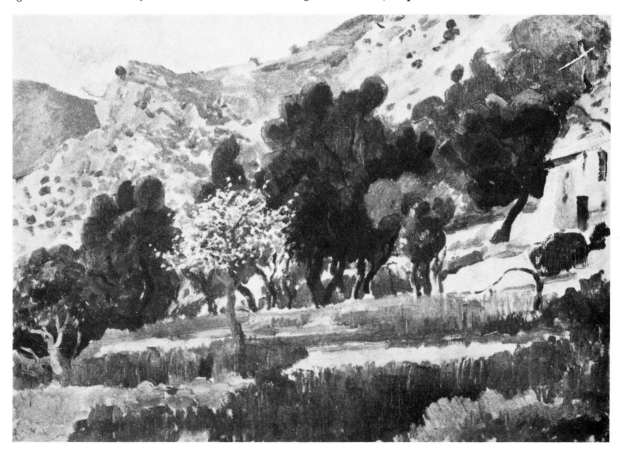

86. SPRING LANDSCAPE AT EZE. Collection of Major Peter Harris

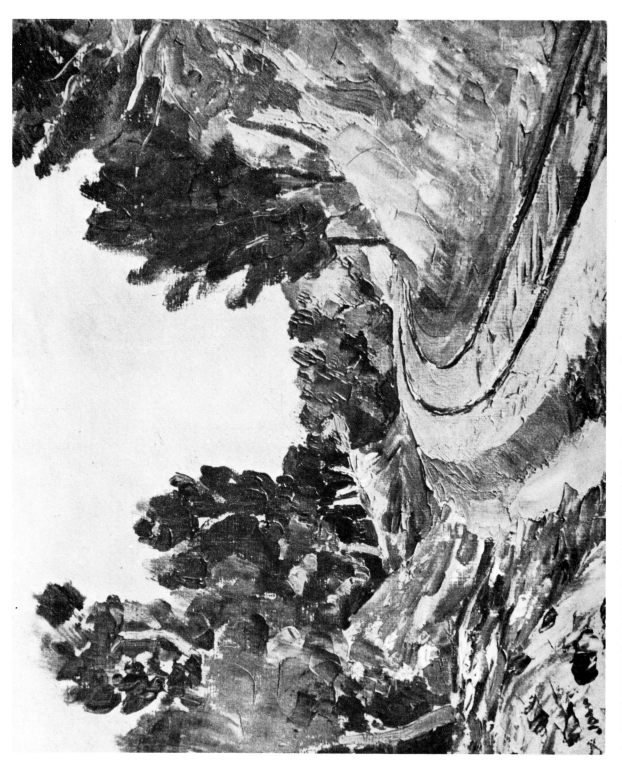

87. THE LITTLE RAILWAY MARTIGUES. The Tate Gallery, London

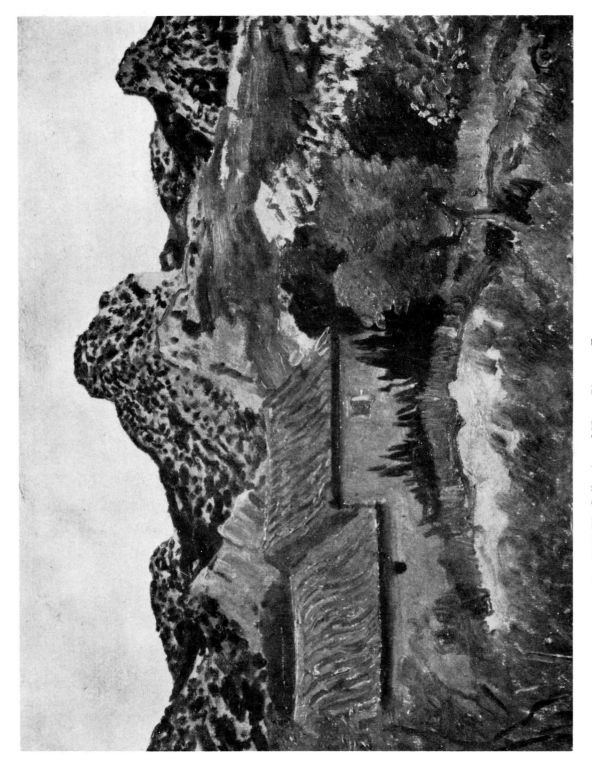

88. ROCKY LANDSCAPE, ST. REMY. Collection of Hugo Pitman, Esq.

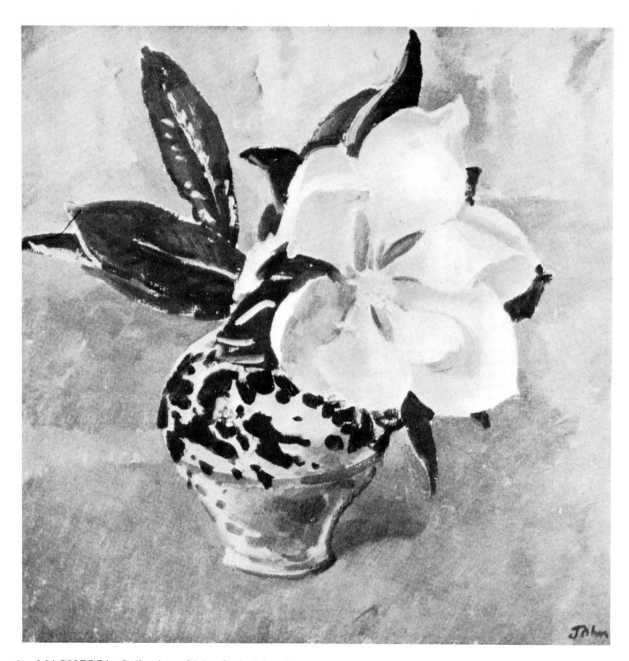

89. MAGNOLIA. Collection of Mrs. Syrie Maugham

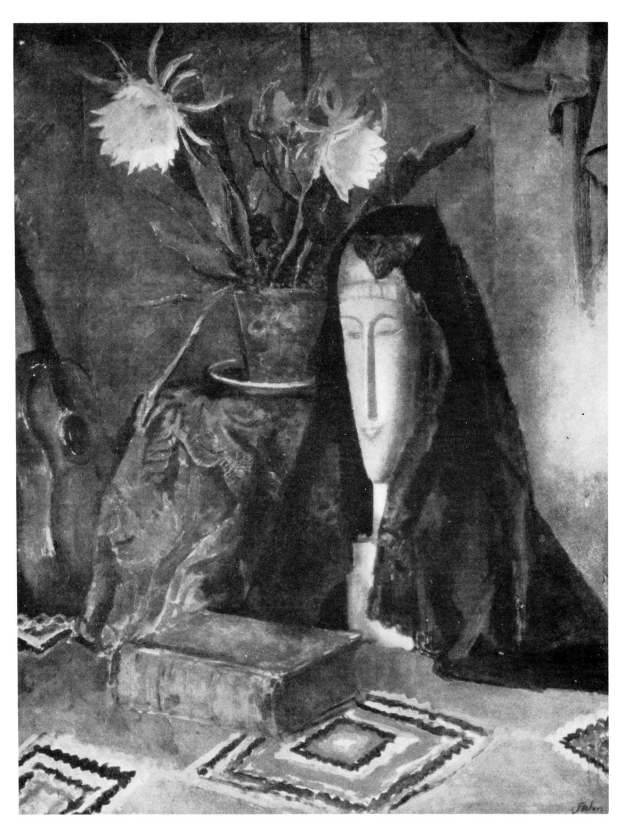

90. IN MEMORIAM AMADEO MODIGLIANI. Collection of A. C. J. Wall, Esq.